M

W9-CKL-210

AUG 2

APR 2 8 2005

SALMON RIVER COUNTRY

Photographs by Mark Lisk
Essays by Stephen Stuebner

CAXTON PRESS
Caldwell, Idaho
2004

Library of Congress Cataloging-in-Publication Data

Lisk, Mark W.
 Salmon River country / photographs by Mark Lisk ; essays by Stephen Stuebner.
 p. cm.
 ISBN 0-87004-441-9 (hardcover)
 1. River life--Idaho--Salmon River--Pictorial works. 2. Wilderness areas--Idaho--Salmon River Valley--Pictorial works. 3. Salmon River (Idaho)--Pictorial works. 4. Salmon River Valley (Idaho)--Pictorial works. 5. Salmon River (Idaho)--Description and travel. 6. Salmon River Valley (Idaho)--Description and travel. I. Stuebner, Stephen. II. Title.

 F752.S35L57 2004
 917.96'820434--dc22

 2004018376

Published by
CAXTON PRESS
Caldwell, Idaho
171399

Printed in China

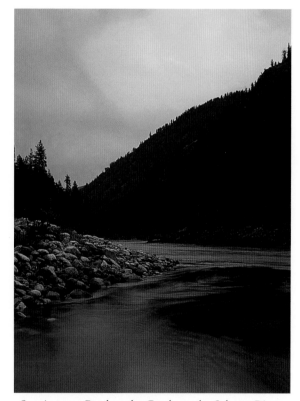

Sunrise over Rattlesnake Creek on the Salmon River.

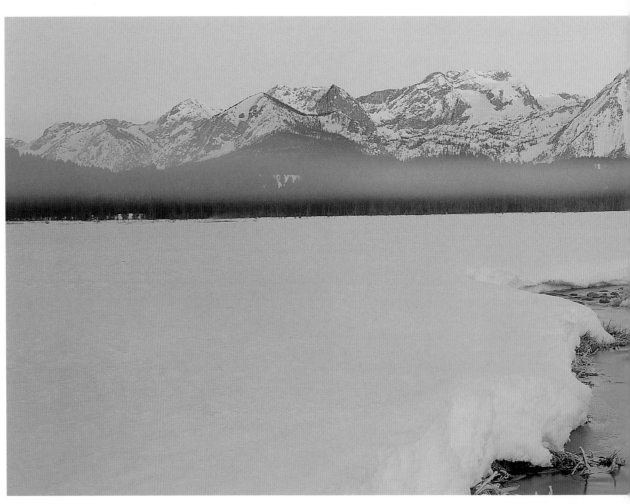

Winter solitude in the Sawtooth Valley.

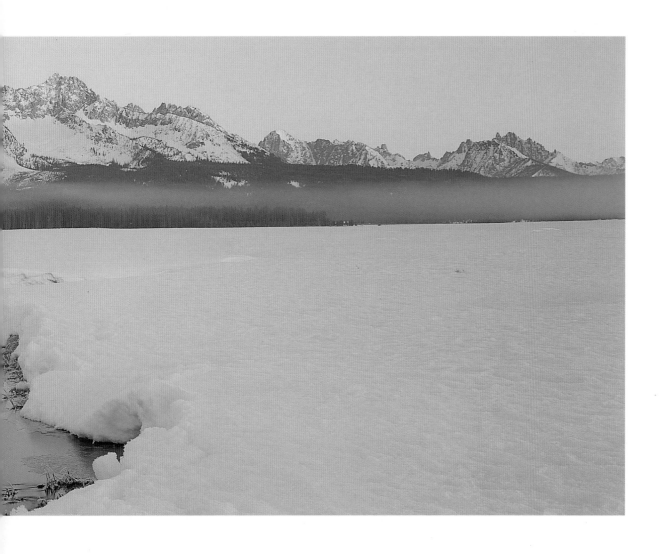

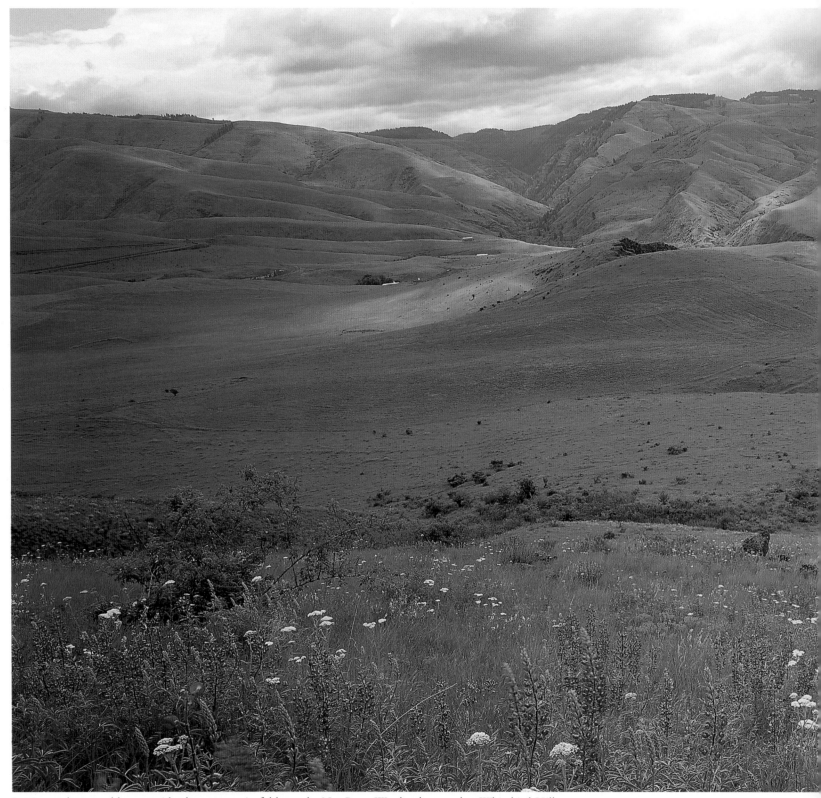

Lupine and yarrow bloom amid velvet mountain folds on the Nez Perce War battleground at Whitebird Hill.

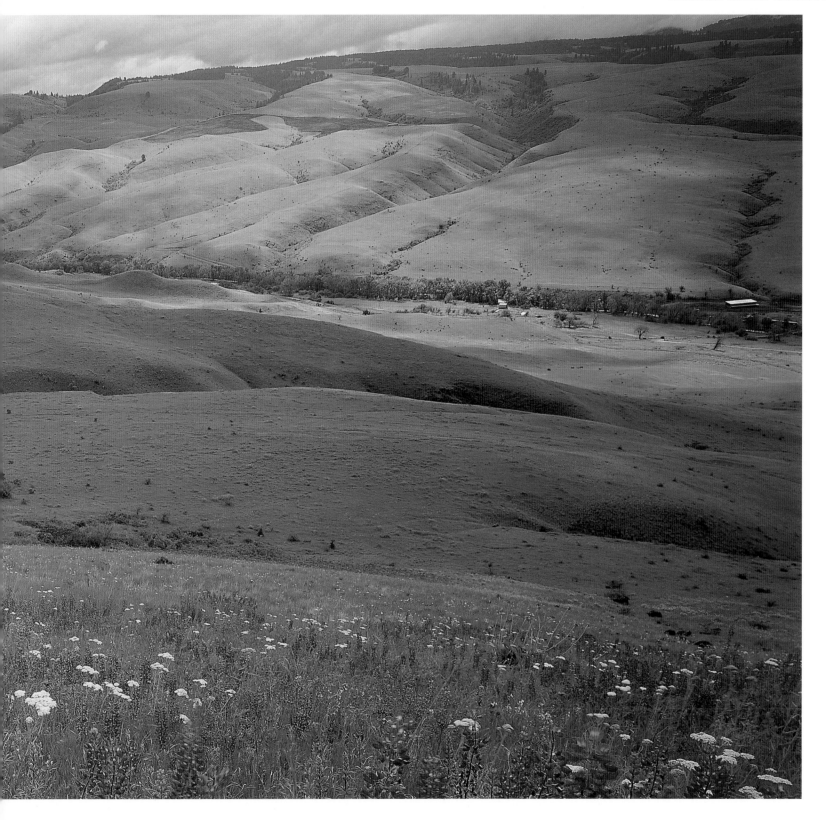

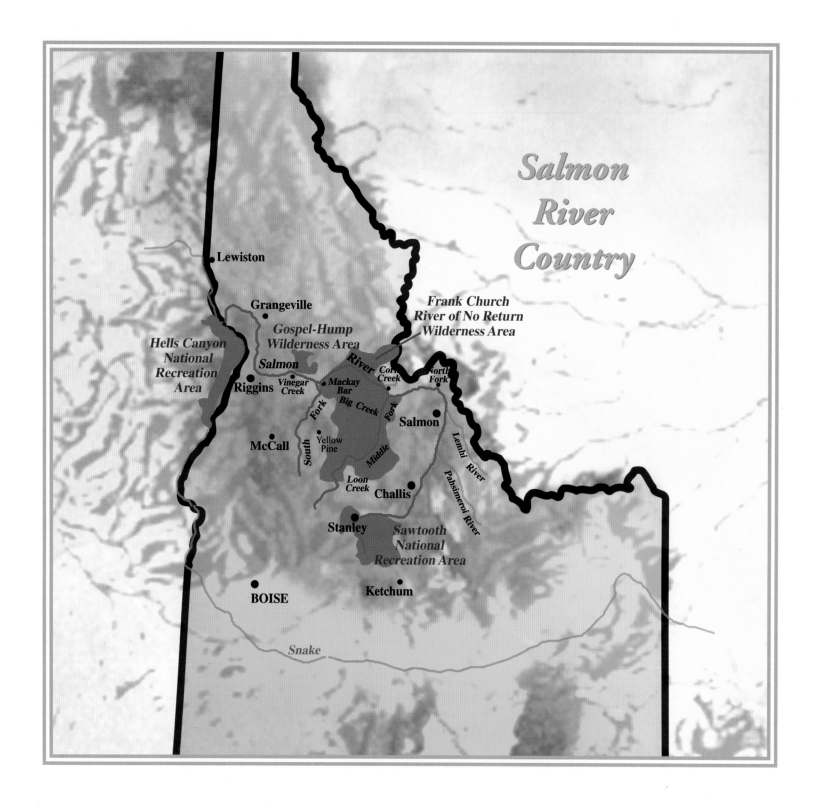

CONTENTS

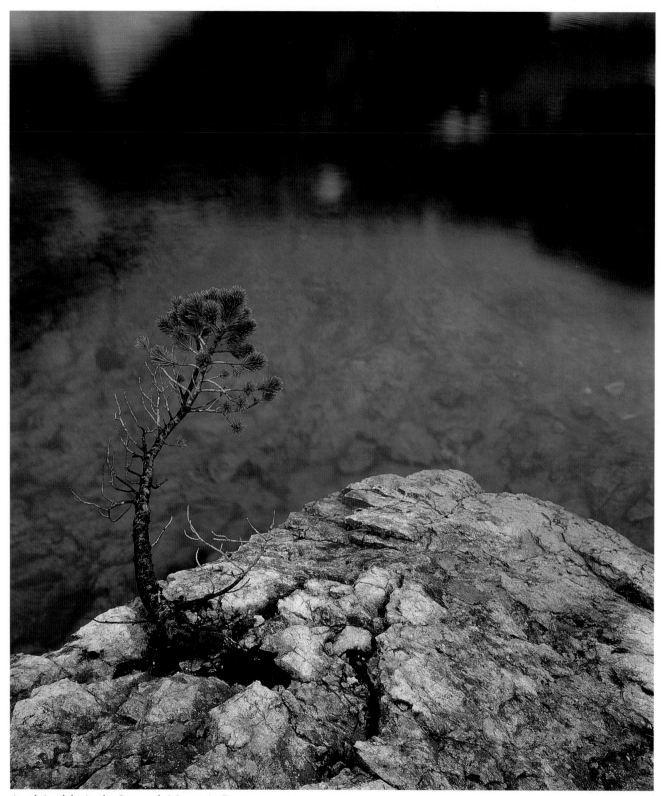

An alpine lake in the Sawtooth Mountain Range.

Welcome

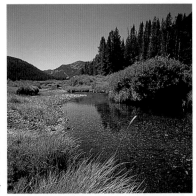

The Salmon River, near the source.

Early on a fine bluebird August morning, a friend and I gobble some grub at the Smiley Creek Cafe and jet off to the head-waters of the Salmon River. After many years of exploring the Salmon River Country by land and river, we are finally trekking to the almighty source.

We follow a primitive doubletrack road through a series of tall-grass meadows bordered by quaking aspen, lodgepole pine, and sage. Here, the Salmon River is a tiny slip of a creek, just two feet wide. We smell the tang of pine and sage as we huff and puff up the road on mountain bikes. Abruptly, the primitive road climbs out of the flat meadow complex, dissolves to singletrack and climbs to 9,000- and 10,000-foot peaks that guard the headwaters divide. Our thighs burning, we encounter a sweet, golden meadow surrounded by dense enclaves of lodgepole pine.

This is the east branch of the Salmon River's source, a lovely scene. A red-tailed hawk circles above, searching for breakfast. Yellow-headed blackbirds cackle in the meadow. Early-morning light casts a bronze glow on the rocky overhanging brow of 10,101-foot Titus Peak and 10,225-foot Bromaghin Peak near Galena Summit.

We push on to see the west branch of the headwaters — the true source. We flush a golden eagle at the summit, and marvel at the stately bird as it hovers in the wind just 50 feet off the ground. Across a small, open meadow adorned with purple lupine, we can see a clear view of three peaks lording over the source. A sweeping ridge forms a gentle arc between a con-ical pine-smothered peak and two beige-colored peaks that lie side by side. They resemble sleeping Indian chiefs, with a horizontal view of a hooked nose and full headdress.

At the top of the ridge, I look north into the vast, mysterious expense of the Salmon River Country. The power of the scene gives me chills.

To the left, the spectacular shower of granite peaks in the Sawtooth Mountains form one book-end of the view, running 30 miles north to Stanley. To the right, the equally grand White Clouds skip down the sky exactly parallel with the Sawtooths. In the middle, the tranquil Salmon River winds through the broad glacial-carved Sawtooth Valley.

From the point I'm standing to the southern boundary of the Selway-Bitterroot Wilderness, more than 180 miles to the north, the 2.4-million-acre Frank Church Wilderness spreads across central Idaho like a massive inland sea of mountains, canyons, creeks, and high lakes. From an east-west perspective, the Salmon River watershed embraces an equally broad swath of mountain terrain, from the Seven Devil's Wilderness atop Hells Canyon on the Oregon border, to the Beaverhead Range along the Continental Divide on the Montana state line. Looking north, peaks jut into the sky like knife points for as far as the eye can see.

This mass of mountain splendor measures 39,600 square miles, slightly smaller than the state of Ohio. It encompasses six different national forests, totaling more than 12 million acres.

"You can't find another chunk of real estate out there that's got that much rugged, primitive mountain territory in the lower forty-eight," says Jerry Myers, 50, a veteran fishing

and boating guide in Salmon who's constantly exploring the Salmon River Country as a lifetime project. "The place is so big it's almost like looking up at the stars and thinking about the land in that kind of infinite scale."

Increasingly, Americans and tourists from throughout the world are being drawn by the beauty and majesty of the Salmon River Country, whether they're here to float the national wild and scenic Salmon River or the famed Middle Fork, passing through to go camping at Redfish Lake, or venturing into the mountains to go backpacking, horseback riding, mountain biking, rock-climbing, or hot springs soaking.

Scores of anglers, hunters and nature enthusiasts are drawn to the Salmon River Country by its bounty of fish and wildlife. Steelhead anglers line the riverbank in the fall and spring in hopes of catching three-foot ocean-going rainbows. Fly fishers ply the Middle Fork and some 850 high-mountain lakes in search of native cutthroat trout. Hunting outfitters fetch $3,000 a person to guide elk, bighorn sheep, black bear, and cougar hunts. RV campers flock to more than 200 campgrounds that circle the basin.

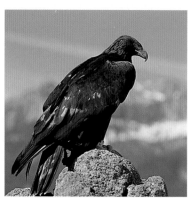

A golden eagle lords over the
Salmon River Country

Every time I visit the Salmon River Country, I feel a tremendous connection between this place and my soul. It has something to do with electric excitement of a momentous recreation adventure looming ahead. But most of all, I think, it's the purity of the place. When I'm trout fishing, I watch the synergy between acquatic insects, pure water, fish and ospreys. When I'm backpacking I marvel at a majestic bull elk grazing in a succulent meadow, or a mountain goat standing on a rocky ridge. Floating the rivers, I watch golden eagles patrol the ridges for marmots and snakes, ospreys diving for fish and, if I'm lucky, I might see a mink or an otter emerge from the water on shore.

Watch closely and listen. There's so much to see and learn. It's a precious place that deserves our utmost respect.

With every new trip that you take, the Salmon River Country will touch your soul. You will yearn to return here as often as possible to discover a new place in the *big wild*.

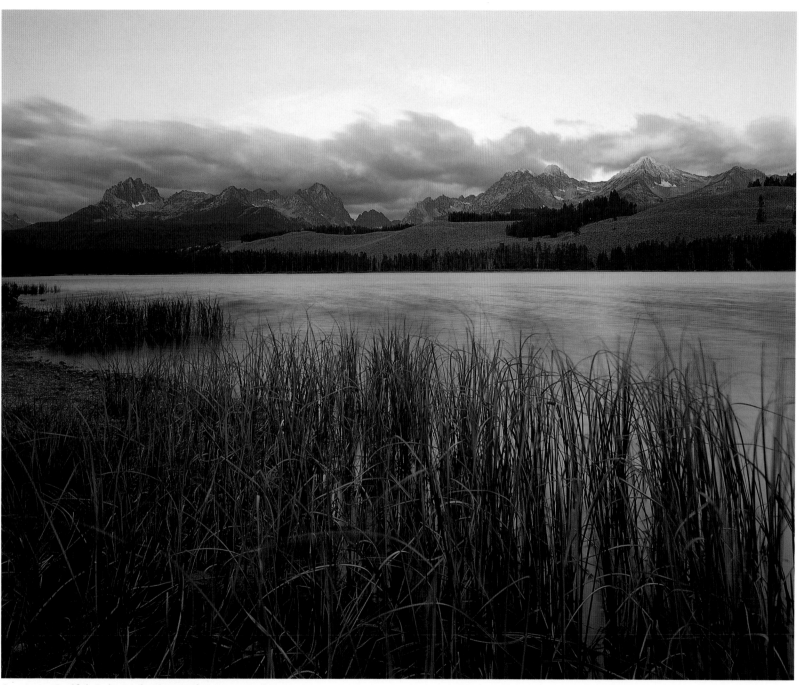

Sunrise at Redfish Lake in the Sawtooth Mountain Range.

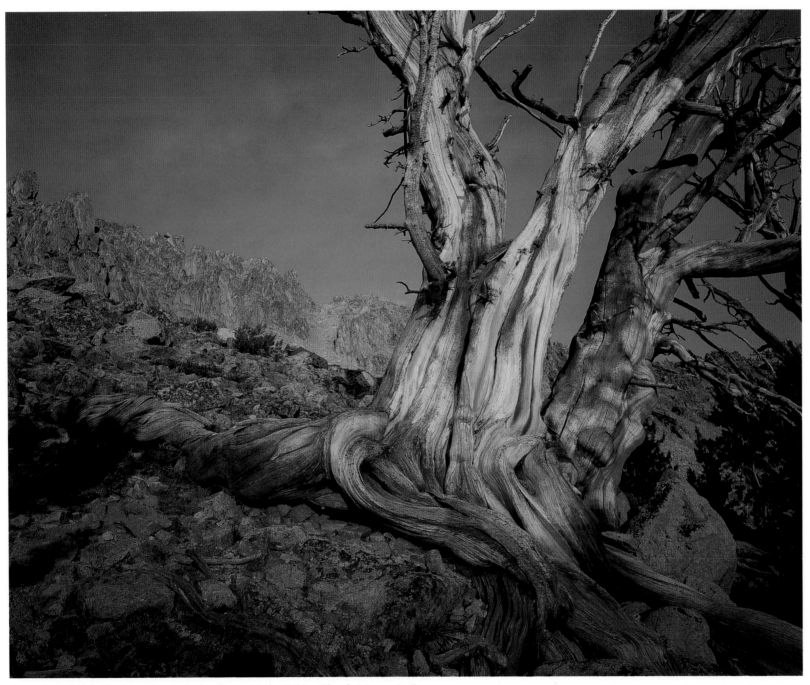

A gnarled whitebark pine mirrors the landscape in the White Clouds Mountain Range.

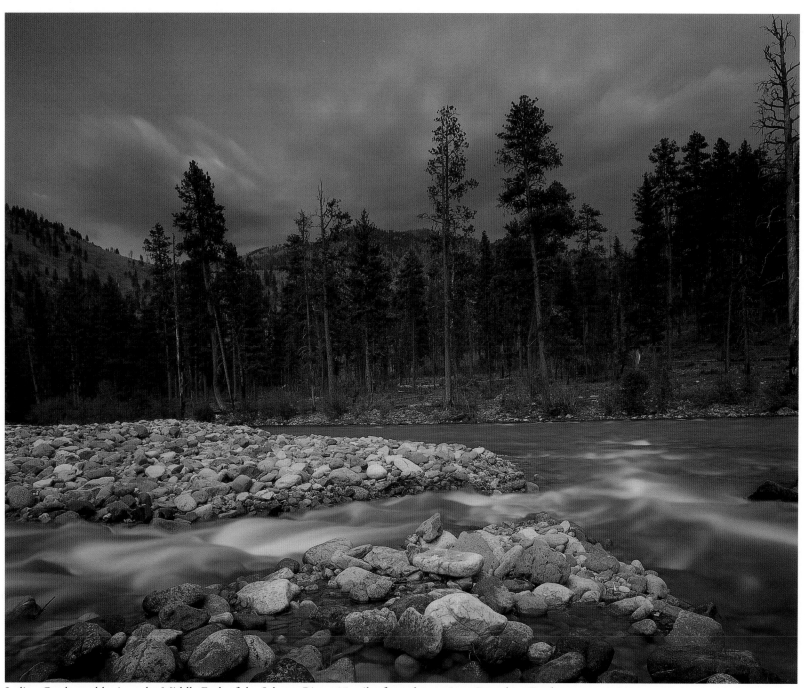

Indian Creek tumbles into the Middle Fork of the Salmon River, 25 miles from the put-in at Boundary Creek.

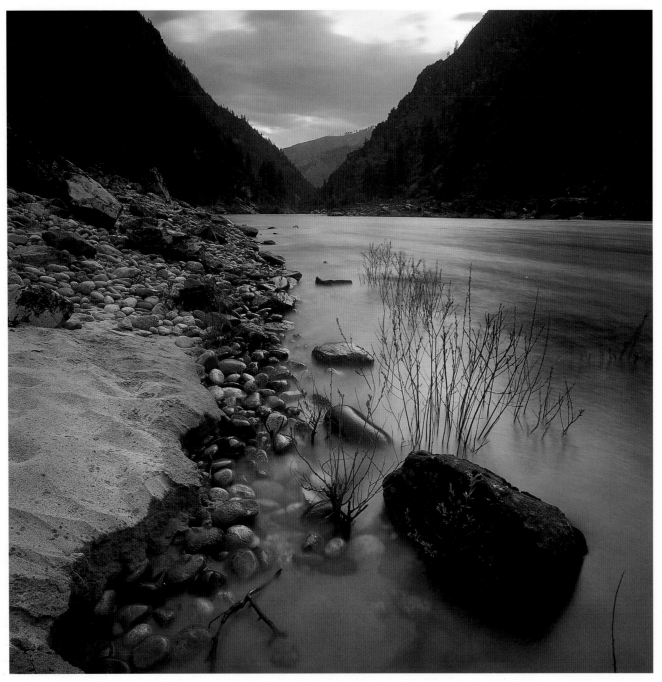

Rafters say farewell to the Salmon River at Vinegar Creek, a boating take-out site, upstream from Riggins.

Chinook

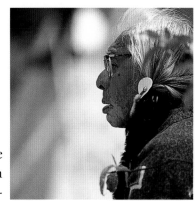
Horace Axtell

On a warm, sun-splashed day in May, the Salmon River Canyon thunders with the rhythmic drumbeat of a salmon ceremony. Seven members of the Nez Perce Tribe, led by spiritual leader Horace Axtell, pound on elk- and moose-skin drums and sing at the top of their lungs in their native tongue, while Riggins outfitter Gary Lane ushers them in a circular motion in the Spring Bar eddy. Lane's gold-varnished dory called *Eclipse* is decked out in Native American regalia, punctuated by a staff of eagle feathers and elk antlers attached to the bow. Eight other boats carry 35 people for the ceremony-in-motion as the boats circle the broad curl of river for exactly three rotations in a clockwise direction.

In the midst of the mesmerizing mix of drums and song, the Salmon River Canyon is transformed into a church. I can sense the moment when the crescendo of sound breaks through every crack in the rocky canyon, penetrating to a subterranean level, while simultaneously infiltrating every water molecule in the river.

At the end of the flotilla's second rotation, two chinook salmon leap out of the river and roll right on cue, sending Axtell a message of their own.

Here in the spring of 2001, the Nez Perce people — *the Nimiipu* — welcome the chinook, the namesake of the Salmon River — back to central Idaho for yet another year. Lane, a mountain man who reveres Native American ways, organizes the affair so that white people can honor the salmon along with the Nez Perce, and perhaps gain a little more respect for the Indian way of life and the salmon. Axtell reciprocates by sharing the ceremony with white people, a rare thing. Religious ceremonies are sacred to the Nez Perce people, and normally, they're performed in the tribe's "Long House" for tribal people only.

"We're here as representatives of two different cultures to welcome the salmon," says a deeply tanned Lane, dressed in a loincloth, his long tresses of brown hair hanging over his shoulders. "I want to thank the creator for the land, the river and the salmon. We're not here to talk about the economic value of salmon, but the spiritual value of the fish. There are two different ways of approaching nature. White man operates in a way that's separate from nature, and Native Americans live in harmony with nature. We know which approach isn't working. Someday, I'm hoping that we can do a better job of promoting a salmon-friendly culture. There's no one better to show us how to do this than Horace Axtell and the Nez Perce people. We still have a lot to learn."

Axtell's nephew "Scotty" lights a bundle of sage for the ceremony. The sweet aroma fills the air as he swings his arm around in circles, casting the tang of sage to all directions.

Scotty introduces his uncle, pointing out that he's very busy these days traveling throughout the United States to give talks about the Nez Perce ways. Axtell is uncommonly open about such things, because he believes in sharing Native American wisdom with white people.

To begin the ceremony, Axtell and seven drummers line up in a row, facing east, next to the boats by the river's shore. Axtell says a few words in Nez Perce tongue to get things started. His gray braids hang down to his waist, the long length

indicating the depth of his wisdom. His weathered face holds the signs of a man who has traveled far and accomplished many things in his 76 years. The lines around his mouth are deeply creased, and his eyes stare straight ahead, into the vast wilderness upstream. He wears a ceremonial vest and moccasins, but no other native clothing, just jeans and a shirt.

A young boy rings a brass bell, a jump call.

"I have a connection to all of this land down this way," Axtell says. "My great grandfather came down here many years ago. He was one of the warriors who fought in the war, trying to uphold our spirituality, our culture and our traditions, the nature of our lands, our way of life, and our connection to nature. My people had a strong connection to nature, the water especially. Water is one of the most important elements of our way of life. Because everybody knows without water, we have nothing.

Nez Perce ceremonial staff

"The next element we have in our way of life is the salmon. The salmon come from the water. The third element is beef, all of the meat that comes from the mountainside. And many different kinds of roots. And the last thing is the different kinds of berries, like the huckleberry. It's one of the last things harvested every year."

The Nez Perce fill the canyon with songs and music. Afterward, Axtell explains what the songs mean:

"You heard the first song, which was our water song, our river song. It takes care of the water. We bless the water all the time with songs like this. The second song was the sunrise. Our people face to the east, and it's a very important song because it symbolizes a new day. These songs are very impor-

tant to our way of life. The third song you heard was a food song — all of the food. The fourth song was a welcome song.

"It's very important, a lot of our people should have to understand that we have a way of life that blesses all of these fish that come up here. Our people who are down here fishing on the river should have been here to enjoy this. It would be a good thing for them to understand.

"For all of these things, we have to thank the creator. For many years, we've been singing for all the different kinds of food, and all of the different ways of life that we have. It's very important to us that we came here to do this.

"So I hope everybody has a good time here, and I hope you understand a little more about who we are and what we do to protect the land and how important it is to sing our songs to the creator, to take care of not only us, but everybody, all living things, and that includes all different kinds of nationalities. So we're not just singing to be singing, it comes from the heart, and we sing these songs to make a connection with the creator.

"The last song that we sang with the bell was to make a bundle of all of the words and all of the things that happened on the river, and we wanted to make a bundle and send it up to the creator with that last song. Now I hope everyone can enjoy what I can smell cooking here.

"Thank you. Isalow. Ya Ya."

The young Nez Perce boy rings the bell.

Now it's time to feast on the delicious reddish-orange flesh of the chinook. A rare salmon-fishing season in the spring of 2001 provides an opportunity for everyone to eat fresh-caught salmon from the Salmon River. At the same time, a few

people stand on the "podium," a granite rock on the big sandy beach at Spring Bar, to say a few words about the fish and the river.

For thousands of years, salmon have been a central part of the Nez Perce way of life. The consumption of salmon is a very important part of the salmon ceremony. The fish are part of the Circle of Life, the many values, religious and cultural traditions that are like the spokes of a wheel, giving strength to the circle, the people, and the earth. The Nez Perce believe that animals have power, called *weyekin*. By worshipping salmon, and eating it, it gives them new strength.

Before we sit down to eat, Lane presents a blond-colored wooden carving of a chinook salmon to Axtell. Everyone gasps at the beautiful piece of art. Then he presents a second gift, a forked horn from a deer. "This horn could symbolize the forked tongue of the white man, and it could represent the hope that our people could someday live in harmony with the land," Lane says.

And then, after the meal, Axtell and Scotty place a gift — a red wool blanket — over Lane's shoulders, and the two men shake hands and hug.

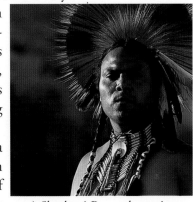
A Shoshoni-Bannock warrior

* * *

Each year in late June, chinook salmon come streaming up the Middle Fork of the Salmon River toward the headwaters, returning to their natal waters. If your timing is right, you can visit Dagger Falls, a tiered waterfall just upstream of the launch site for the national wild and scenic Middle Fork, and watch the chinook leap the falls.

On June 25, I nail it.

It is a high-water year, with deep snow in the mountains — a big pile of water flies over the falls. I'm sitting on a high bank overlooking the falls 35 feet below. At the bottom, a large recirculating hole bisects the river, leaving two six-foot waterfalls on either side. The best bet for the chinook is to leap into the left or the right channel and plow upstream.

There!

I see the first big chinook leap into the froth in the left channel. The fish muscles its way past the teeth of the current and proceeds upriver. A few minutes pass by, and then another whopper jumps the falls. Each time, the sight takes my breath away. Here they are, more than 750 miles from the sea, and they're still stronger than anything I can imagine. I know how much strength it takes to swim against the raging current and prevail. A human couldn't do it — not even with fins. Every once in a while, a chinook gets belted back downstream by the rushing water, and has to make a second or third leap to move on to its spawning grounds. Eventually, the fish always make it over the falls. What a spectacle!

Nearly 200 years ago, when Lewis and Clark and the Corps of Discovery first laid eyes on the Salmon River, William Clark named it the Lewis River, after his partner, Captain Meriwether Lewis, who had been the first white man to see it. Later, the river was renamed the Salmon because it teemed with salmon — chinook, coho, and sockeye. During the summer migration, every tributary stream was choked with literally thousands of salmon from bank to bank. Old-timers joked about walking on water, skipping across on the backs of salmon without getting their feet wet. They used to harvest chinook with pitch forks.

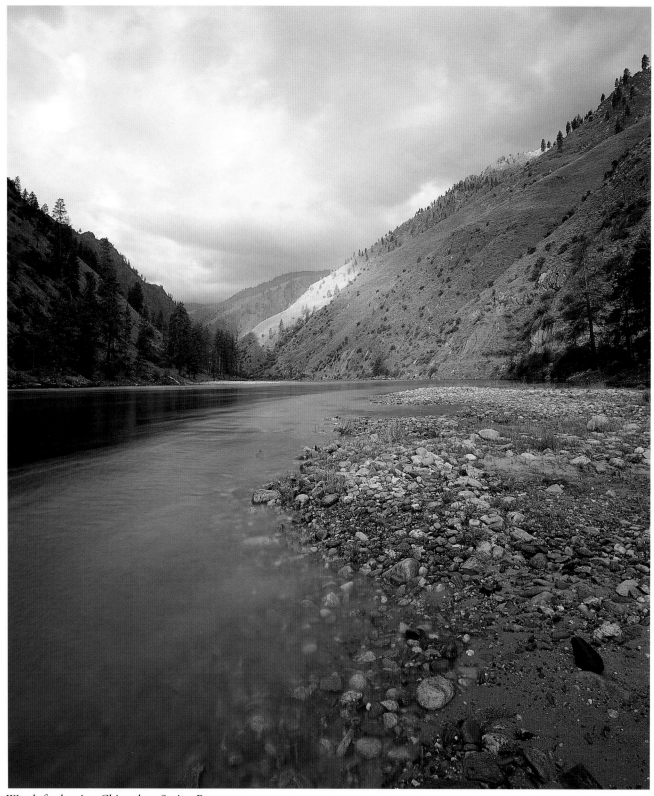

Watch for leaping Chinook at Spring Bar.

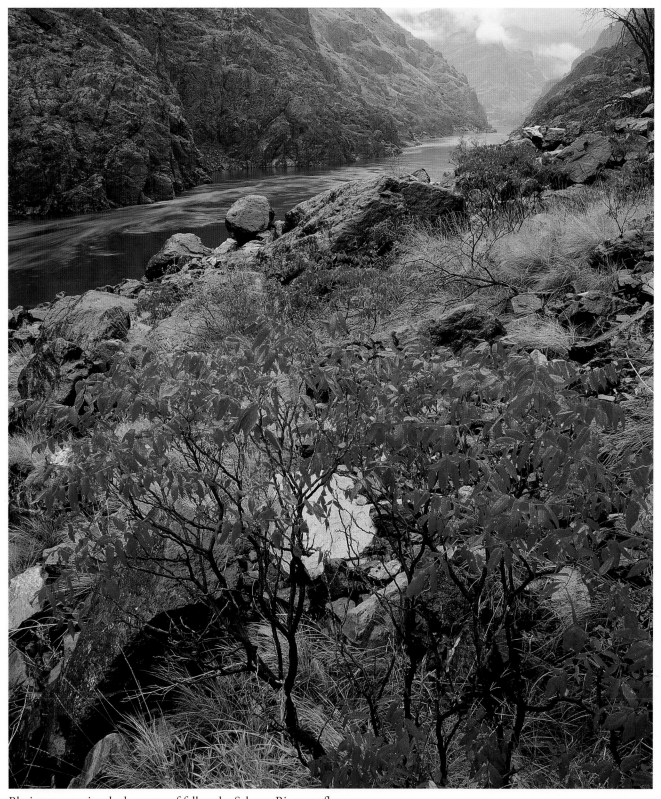

Blazing sumac signals the onset of fall at the Salmon River confluence.

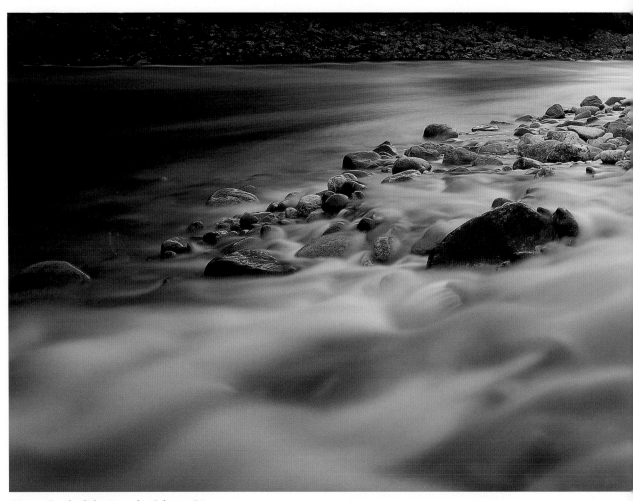

Horse Creek glides into the Salmon River.

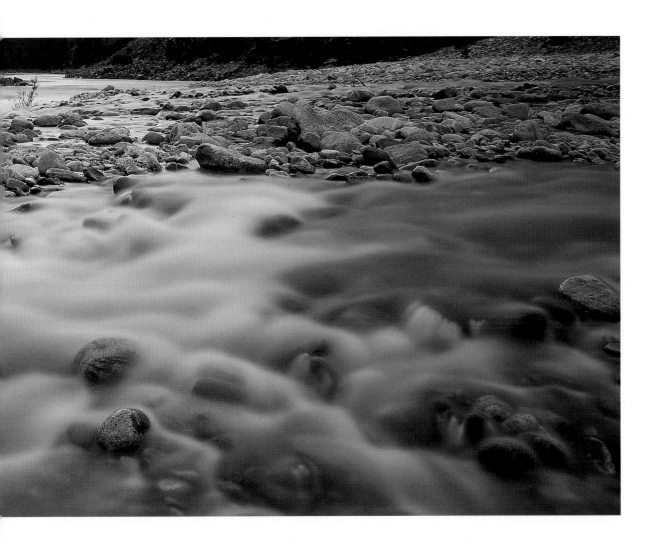

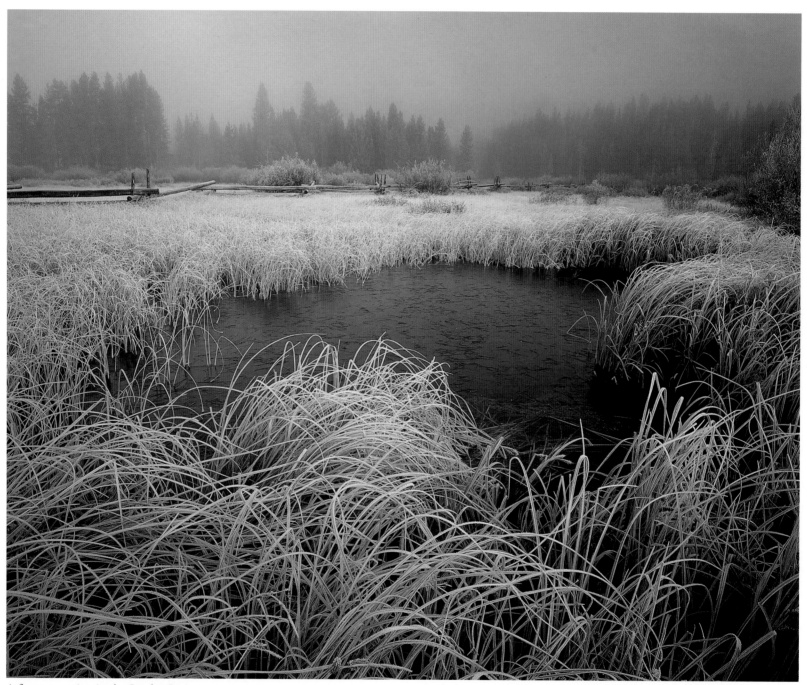

A frosty morning in the Stanley Basin.

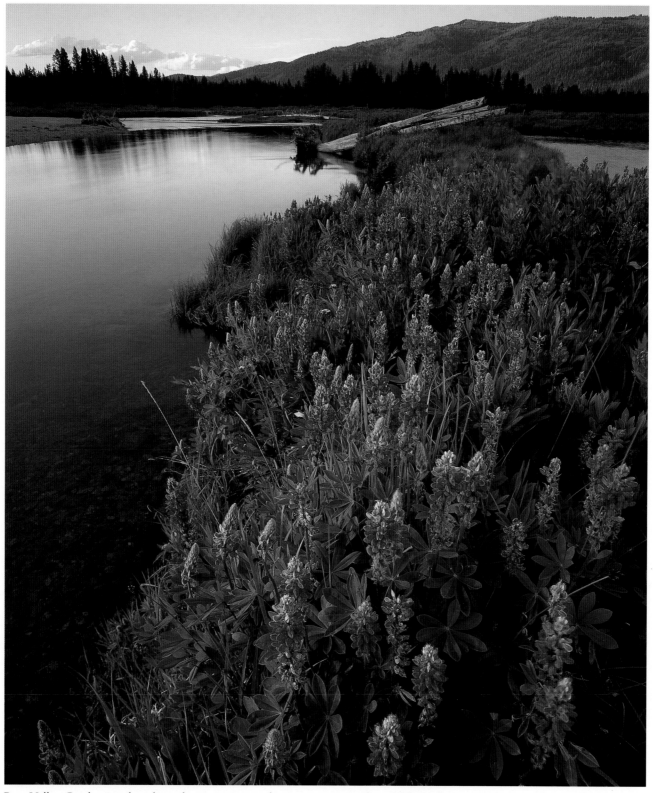

Bear Valley Creek meanders through mountain meadows on its way to the Middle Fork.

But now, at the dawn of the 21st century, a person can stand at Dagger Falls and wait for 15 minutes to see a single fish make the leap. Today, there is a distinct possibility that the Salmon River's namesake could become extinct. At the prompting of salmon-advocacy groups, Salmon River chinook and sockeye salmon were added to the endangered species list in the early 1990s. Coho salmon became extinct in the 1970s. The sockeye are crimson-red fish whose adult numbers can be counted with one hand.

But the chinook are still hanging on.

In the summer of 2001, more than 185,000 chinook were counted as they passed Lower Granite Dam, the last dam out of eight that the fish have to climb over between Portland, Oregon, and Lewiston, Idaho, on their way back to the Salmon River. Over the previous 10 years, an average run consisted of about 85,000 fish. The 2001 migration season gives everyone a big ray of hope. The Middle Fork of the Salmon remains the backbone of the wild chinook runs in the Salmon River system. Its waters are pure and clean, and the spawning grounds are pristine. Two salmon hatcheries, Sawtooth Hatchery near Stanley, and Rapid River Hatchery near Riggins, have helped keep the runs alive.

A variety of factors are blamed for the decimation of the salmon, including eight dams on the lower Snake and Columbia Rivers, avian and fish predators, water pollution, high water temperatures caused by industrial wastewater discharge, and during some years, poor ocean-survival conditions.

The core migration corridor between Lewiston, Idaho, and Portland, Oregon, has become a hydroelectric factory that produces cheap power for industries in the Northwest, reducing the Snake and Columbia Rivers to a series of slackwater shipping lanes for barge traffic. Sadly, the debates between the powerful industrial interests and fish advocates are now called the "salmon wars."

Dagger Falls

Keith C. Petersen, author of *River of Life, Channel of Death,* concludes that the salmon may not survive over the long term, "In the period from the 1970s into the 1990s, the Corps of Engineers and other state and federal agencies pumped hundreds of millions of dollars into fish preservation efforts while maintaining the dams at peak operating efficiency for electrical production, navigation, recreation and irrigation. No where in the world had society spent anywhere near as much money to preserve fish runs as on the Columbia River system. Despite all that money, the fish continued to die."

It may "prove impossible to have low hydroelectric rates, free navigation and viable fish runs in the Columbia/Snake waterway," Petersen says.

Even so, the salmon have shown amazing resilience. They have been making the annual pilgrimage from the Pacific Ocean to central Idaho for more than 5,000 years. They're not about to give up without one hell of a fight.

No one blames the conditions in the Salmon River Basin for the chinook's demise. As the longest free-flowing river in the lower 48 states, the Salmon River is free of dams, and its waters are pure, surrounded by wilderness. As one salmon expert put it, "We've got a five-star hotel in the Salmon River, but most of the rooms are empty."

* * *

By late August and early September, the chinook have climbed a vertical mile from sea level to their spawning grounds in the headwater streams of the Salmon River. At this time of year, I like to visit Stolle Meadows near Cascade, Idaho, and belly-crawl through hip-high grass to get a glimpse of the magnificent fish in their final act, the mating dance. On a weekday afternoon, a friend and I have the mile-wide meadow to ourselves, if you don't count the black bears.

We walk across the meadow, and find a real dandy of a spawning scene in no time. In the center of the stream, at least five male chinook try to get a piece of action with a lone female. We get down on our hands and knees and crawl, ever so slowly, to the edge of the stream, and part the grass with our hands, being careful not to spook the fish. The water in the South Fork of the Salmon River is low, exposing the chinook's beat-up white tails and dorsal fins on the water's surface. The fish have been fasting for months now. They are nearly three feet long, but skinny as a blueprint tube. The female chinook, all bright and shiny with a green body with black spots, lazily hangs over the top of the spawning nest, the *redd*, waiting for the males to sort things out. The boys chase each other around the edges of the redd, trying to bite each other and angle for superior position. Then, once the coast is clear, the toughest male fish sidles up next to the female and releases his sperm on top of her eggs. Then, they use their tails to push gravel over the top of the eggs, which will hatch the following spring.

For me, it's a treat to see all the action. I ponder the great mystery of their life cycle — how they were born at this very

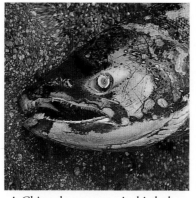

A Chinook returns to its birthplace

spot, more than five years ago, and began the epic 800-mile journey to the sea. After swimming through the steep rapids of the South Fork, the fish turned left on the main Salmon, turned right on the Snake River, navigated the gauntlet of eight dams in the migration corridor, and entered the vast Pacific Ocean, as a salt-water fish. They would remain in the Pacific for one to three years, and begin the journey home in the springtime. Somehow, they knew how to sniff out the mouth of the Columbia and turn into a freshwater creature again. They had survived the industrial corridor once again, and continued to swim upriver to the mouth of the Salmon, turned left, cruised up to the South Fork, turned right and swam another 120 miles to their spawning grounds. What a magical journey.

It's a sobering thought to imagine what these fish had been through, and what their future will hold. I sit in the grass and listen to a gentle wind blowing through the lodgepole pine and Douglas fir trees bordering the meadow, and to the *rat tat tat tat* of a kingfisher working the bank. I watch a bald eagle fly overhead. The eagles will have plenty of food to eat this fall, after the chinook, all spawned out, roll over and die.

Right at that moment, I feel a tug of melancholy and exhilaration. It's such a neat experience to see the chinook in the final act of life, and see it so close, without anyone else around. But at the same time, it's depressing to realize that my two boys might not be able to show this ancient ritual to their children.

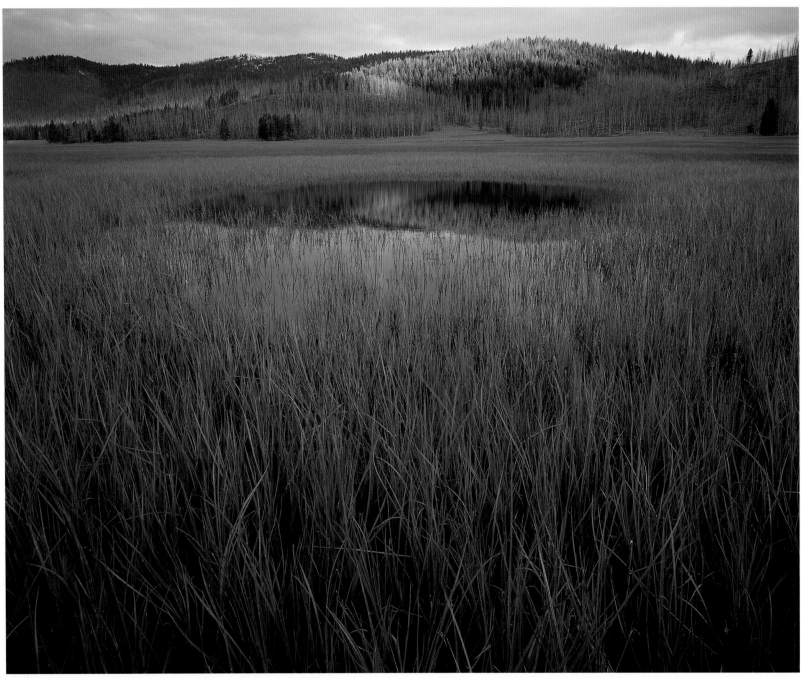

Listen for wolves in expansive meadows perched above the Middle Fork.

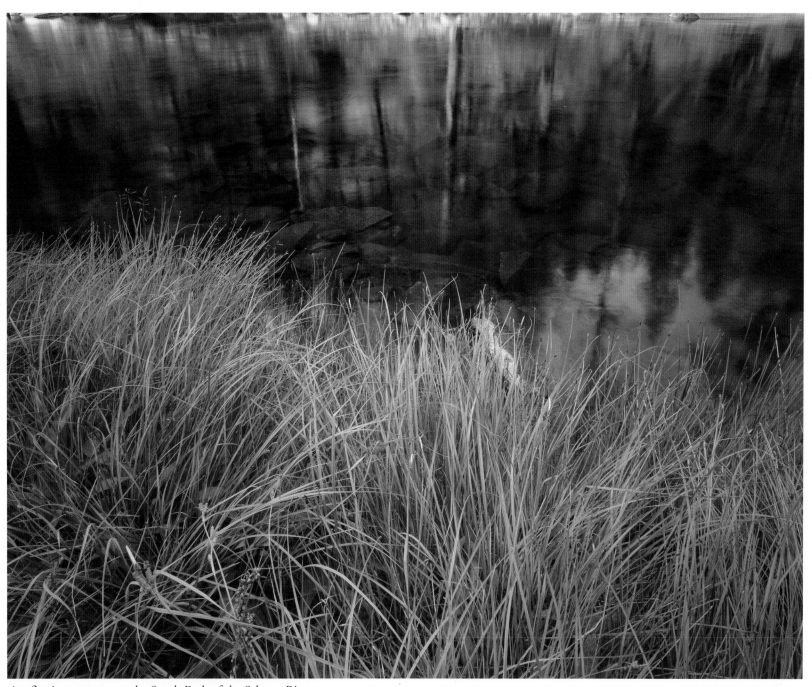

A reflective moment on the South Fork of the Salmon River.

Salmon River profile
Bethine Church –
From visionary to legacy

When Bethine Church drives over Galena Summit to vacation in the Salmon River Country, it feels like coming home.

As a little girl, she spent her first Christmas at her family's Robinson Bar Ranch, dressed in a snowsuit, sleeping on a sheepskin rug. From that point on, she spent every summer there with her family. In 1927, she married young senator-to-be Frank Church on the front porch of the ranch.

"Every time I come up here, and see the Sawtooths for the first time over the top of the pass, it gives me a little tug," she says.

Her dad was former Idaho Democratic Governor Chase Clark. She called him Pop. A lawyer and skilled politician, Clark also knew how to size up a piece of land — the Robinson Bar Ranch is perhaps the most choice piece of private real estate in the Stanley area. It's a 123-acre spread, with its own hot springs pool, a stately mansion, and more.

As the wife of an Idaho senator who served 24 years in the U.S. Senate, Bethine is a stunningly intelligent woman, and she's very warm and engaging. Her upbringing in the Salmon River Country taught her how important it was to preserve a special area in its natural condition. Her husband understood that, too, as a native Idahoan who spent time in his youth camping with his family and fishing. In an interview in a red gazebo on the banks of the Salmon River in Lower Stanley, Bethine bubbles with enthusiasm as we reflect on all of her and Senator Church's achievements.

When Bethine and Frank Church saw unsightly development cropping up in the Sawtooth Valley in the 1960s, they knew something had to be done. "We came over Galena, and looked down, and here was this whole valley being cut up with telephone poles, little triangular shacks on quarter-acre lots, and roads being bulldozed through all of it," Bethine says.

"It was the ugliest thing you ever saw. Frank said, 'Bethine, this just can't happen to this area! No one realizes how truly magical the Sawtooths are, and this will ruin it.'"

Frank Church led the floor debate in the Senate in 1964 to create the Wilderness Act, a monumental piece of legislation. The bill also created 9.14 million acres of "instant" wilderness areas, national crown jewels over which there was no dispute, including the 1.2-million-acre Selway-Bitterroot Wilderness in northern Idaho. Eventually, he would work to pass four bills that changed the fabric of the Salmon River Country forever — legislation that created the 754,000-acre Sawtooth National Recreation Area and the 217,000-acre Sawtooth Wilderness, the 220,000-acre Gospel Hump Wilderness, the National Wild and Scenic Rivers Act, and the 2.4-million-acre Frank Church-River of No Return Wilderness.

The political coalition that created the Sawtooth NRA legislation included then-Governor Cecil Andrus, Wilderness Society board member Ernie Day of Boise, Senator James McClure, R-Idaho, and many others. The final legislation made the protection of scenic values, wildlife, and salmon and steelhead squarely as the top priority.

A key aspect of that bill is that it called on Congress to appropriate money to purchase scenic and conservation easements on Sawtooth Valley and Stanley Basin ranches to prevent development. The bill also required the Forest Service to preserve the wooden worm fences that everyone sees as they pass through the NRA, a nifty touch.

The easement concept worked. Today, the Sawtooth Valley and the Stanley Basin appear to be frozen in time. The pastoral feeling of the land — a special quietude surrounded by beauty — has been preserved forever.

Bethine recalls it wasn't as difficult to get the Sawtooth NRA bill passed in Congress, compared to the Gospel-Hump and the River of No Return bills. For those two acts, Senator Church took a lot of heat.

"You know, Frank never did anything that wasn't controversial," she says. "When he did the Gospel-Hump Wilderness, they hung him in effigy in Grangeville."

The storied debate to create the River of No Return Wilderness could be a chapter in a book. Senator Church believed a major compromise would be necessary, because it would be impossible to protect the 2 million acres some proponents wanted. But with a political coali-

Bethine Church

tion that included jet boaters, fishing and hunting outfitters, airplane pilots, as well as wilderness advocates and environmentalists, they got it done.

They drew lines around the historic mining areas and potential new mining areas. They "grandfathered" in dude ranches and private homesteads, meaning they would be allowed to stay, or were later purchased and removed by the government.

Despite a lot of opposition from people who lived in the region, the bill passed.

"If Frank really believed in something, he'd do it," she says. "He really was for keeping not only our heritage that people had built, but for keeping the country so people had a chance to see it in its pristine glory."

The year the River of No Return Wilderness bill passed Congress, in 1980, Church was defeated by Republican Steve Symms, who was swept into office by the conservative tide that elected President Ronald Reagan.

Three years later, Senator McClure carried a bill that added Frank Church's name to the River of No Return Wilderness, when Church was battling cancer, a rare fight he didn't win.

Today, Bethine is busy as the matriarch of the Idaho Democratic Party and as a grandmother. A number of years ago, she formed the non-profit Sawtooth Society to assist with fund-raising and improved management of the Sawtooth NRA. She's still working to make sure funds are available to purchase scenic easements on private land that's still unencumbered.

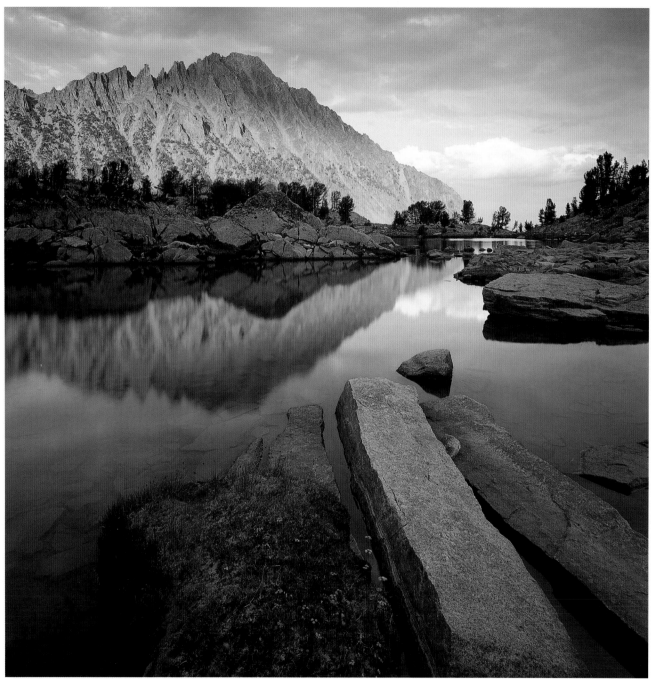

Chamberlain Basin peers out to Castle Peak in the White Clouds.

The Land

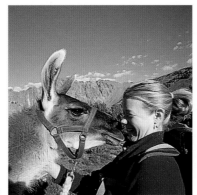

Jo Myers gets a nose-tickle

Bear Valley Creek Trail in the Lemhi Mountains slowly gains altitude while running alongside the stream for which it is named, underneath dense fir and pine. But the ease of the beginning is deceiving. At mile three, the trail starts to get progressively steep.

I'm about four miles up the trail now; it's late afternoon, and my shoulders and hips are burning from the stress of carrying a heavy backpack. This could be worse, I'm thinking, since our guide, Bob Russell, has strapped my tent on the back of his lead llama, a dark-haired skittish fella named Skye. But the 3,000-foot vertical rise and high elevation in general is beginning to get to me.

My buddy Mark, meanwhile, is snickering behind me, watching me bob and weave on the trail, while he's barely breaking a sweat. He's carrying a pint-sized pack, requiring me to carry most of our food, and all of his camera gear is loaded on Russell's pack string of four llamas. Mark has never had it so easy.

When we finally reach Bear Valley Lake, the pain vanishes as a glorious setting opens up before our eyes — a large turquoise lake framed by a tall conical peak on the left, and a whale-like rocky talus ridge to the right. Fish are rising everywhere.

Since the llamas carry all of our kitchen gear, Russell can set up a deluxe camp. He has a blue roll-up table, small tripod chairs for all of us, a double-burner stove, and two coolers full of ice, one of them stuffed with cans of Heineken and Corona.

The next morning, 17-year-old Jo Myers, Mark, and I head up a rocky talus ridge on the north side of Bear Valley Lake to climb a nearby peak, 10,700-foot Tendoy Mountain.

It's a cool, refreshing morning, and the air is scrubbed clean by the wind. It's a relatively easy walk up the ridge, watching out for loose boulders, and within an hour and a half, we reach the top. "You can see all the way to the Pioneers!" Mark says.

"No way," I shoot back. "Think how far we are from there. We're closer to Idaho Falls than Hailey."

When I soak up the full 360-degree view, however, there is no doubt: The distinct shape of The Devil's Bedstead looms on the north end of the range. The longer I look, the more the stupendous view just hits me over the head, causing a few howls of pure joy. Let's see, there's the Lost River Range and Mount Borah to the south, and across the Big Lost Valley, there's the Pioneers, the Boulders, and the White Clouds. Straight to the west, the Bighorn Crags, the Yellowjacket Range and Salmon River Mountains poke into the sky. To the north, we can see the Beaverheads, the Bitterroots, and very faintly, a piece of the Selway country.

Looking down the spine of the Lemhi Range, we see brutish dark and bold peaks and razor-thin ridges run down the line, and here we are, right on top of it all.

Ten mountain ranges — that's the most that Mark and I have seen from any high perch in the Salmon River Country.

Over the years, we've been hiking into the region from all directions of the compass, so we're impressed. This is the kind of daunting vantage point that reminds me how much country I still need to explore.

Then, a golden eagle whips across a pass below us and soars into the Lemhi Valley.

"Wouldn't it be cool to be like an eagle and have wings?," Joe says.

Oh yes. And that's the mission of our journey in the Salmon River Country — to explore every corner of the watershed in hopes of not only finding new places to play, but also to glean new wisdom — and some humility — from the whole experience.

* * *

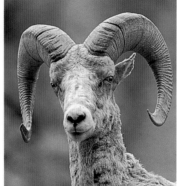
Wild sheep near Shoup

North of the lakeside alpine community of McCall, Idaho, a paved highway to Burgdorf Hot Springs passes over Secesh Summit into the Salmon River Country. The drive passes Payette Lake and Upper Payette Lake in the headwaters of the Payette River drainage, a clue to what the white-granite mountains have to offer in the headwaters of the Secesh River and Little Payette River on the other side. The whole Payette National Forest, north of McCall, is chock full of high mountain lakes, some obvious, many of them hidden in the high peaks.

Four of us drive up to the area today to mountain bike the Ruby Meadows-Loon Lake Loop, a 25-mile advanced ride that provides a glimpse of everything that's special in this area — mountain meadows, deep woods, wildlife, wildflowers, granite peaks, high lakes, creeks and rivers.

In my view, the Loon Lake ride is an Idaho Classic, a term reserved for the state's most primo rides. We begin by riding up a two-track road that winds through a lodgepole forest before dropping into Ruby Meadows, where moose are often visible. The mosquitoes can be fierce, too. Today, there's no bugs, and there's a new bridge crossing the creek, a nice improvement.

We climb at a moderate speed to the top of the meadow complex on a nice tacky trail bordered by thick lodgepole. I remember seeing and hearing a great horned owl in this area when I rode the loop 10 years ago. At the top of the Ruby Meadows divide, the trail narrows to singletrack and dives into the Willow Basket Creek drainage, another series of grassy meadows bordered by naked lodgepole trees. The trees burned several years ago, the charred bark fell off, and now the stems are shiny blond.

Along Willow Basket Creek, the familiar smell of pine, skunk cabbage and wildflowers fills the senses. Make-shift wooden bridges (logs bundled together) help protect the meadow, but they were built more for horse and foot travel than mountain bikes. Mark tries to ride one of them, and his back wheel gets shoved into a stout overhanging branch, breaking a spoke and throwing his rear wheel out of true. He gets tossed over his handlebars into the brush, injuring his shoulder.

"I thought maybe I popped it out, but it's not dislocated," he says.

We jury-rig Mark's wheel and keep going — no significant harm done. Soon, we reach a junction with the Victor Peak Trail from Chinook Campground, and climb toward Loon

Lake. Here, morning sun illuminates green bear grass, ferns and moss in the forest floor with a brilliant shaft of copper light.

It's a bit of a pull, a granny-gear climb to Loon Lake, but well worth the effort. It's an enormous lake, compared to many high lakes, nearly a mile long. Often times, I've seen a moose next to the lakeshore or swimming in the lake when I arrive. This time, we're not as lucky. We see a moose and a few ducks swimming around and avocets in flight, but no loons today. The view across the lake is classic and impressive. Snow-streaked Victor Peak lords over the valley on the left, and a tall unnamed peak stands on the right, completing the frame. An old plane wreck lies hidden in the trees on the lakeshore.

We munch some lunch, pose for a few post-card-like pictures and then we take off. It's a fun,

Steelhead fisherman displays catch

two-mile steep descent to the Secesh River, all on singletrack. I pass a couple of mountain bikers who didn't realize that the short loop from Chinook Campground should be ridden counter-clockwise to avoid climbing and walking that steep pitch. Oh well, now they know.

We cross a bridge over the Secesh and ride the riverbank trail for about four miles, up and down, up and down, to Chinook Campground. "Wow, that was even better than Fisher-Williams," Mark says, referring to another Idaho Classic in the White Clouds. "I really liked riding through the meadows, to a lake, and along the river. That was cool."

Our riding partners, Ross Corthell and Morgan Dethman-Corthell, sported big grins, too. "It was a wonderful ride," Ross says. "Climbing back to the campground was really nice on that singletrack. It was hard, back and forth, steep ups and downs, technical, and then the beautiful river. I liked how you'd climb away from the river, and then drop back down to it, it was nice."

"There was lots of variety and terrain, very scenic, but it doesn't burn you out," adds Morgan. "That was a nice surprise in the middle at Loon Lake, a great lunch spot."

And then, to top it all off, you must soak in the soothing cobalt-blue water at Burgdorf Hot Springs.

Off to the east from here, near Stanley, a wealth of mountain biking opportunities abound in the White Cloud Mountains and the Salmon River Mountains. The 18-mile Fisher Creek-Williams Creek Loop is one of the sweetest rides imaginable, with buffed singletrack, fetching views of the Sawtooths, and ripping fast downhills. It's the most well-known ride in the Sawtooth Valley.

Hook up with Stanley resident Jack See and Brent Estep, owner of Mackay Wilderness River Trips, whose warehouse is located in Stanley, and they reel off a dozen rides that no one else has heard of. I rode an epic loop in the White Clouds with Estep on a cool September day, and we were in the saddle for more than six hours of continuous riding (with a few rest stops). Boy, we were glad to see my truck in the late afternoon.

See, former manager of the Redfish Lake Lodge, started mountain biking in earnest in the early 1990s. "Once I started riding, I realized that I could expand my horizons so much more than hiking. It opened up a whole new book of possibilities," he says. " It's like, what's your vision quest this week? There's always been a trail in the back of your mind, wondering if it will go through."

After more than five years of route-pioneering, See still has a few uncharted areas on his list. "It's always great to get out and explore, and you never see another rider."

* * *

Up and over the top of the Yankee Fork country, a winding dirt road leads to the headwaters of Loon Creek, ending abruptly at the Loon Creek Trailhead and the Frank Church Wilderness boundary. Mark and I had always wondered what it would be like to hike down the length of Loon Creek to the Middle Fork, and check out the fishing and the scenery.

The Loon Creek trail doesn't get much use by backpackers because of difficult access — the long drive to the trailhead, and the quandry at the end of the trip. If you hike all the way to the Middle Fork, you either have to fly out at the Simplot Ranch or catch a ride with a float-boat party, with 50 miles left to go on the Middle Fork. We arrange for a flight back to Boise at the end of our trip.

On our first day, we hike about five miles to an excellent natural hot springs for our first night's camp. The springs are located on the right side of the creek, next to the river and an old miner's cabin. Previous visitors had built several rock-lined pools that are a couple feet deep, perfect for soaking.

Early in the day, we realize that the trout fishing is phenomenal. Big cutthroat trout, which act like they haven't seen a grasshopper for years, eagerly rise to the surface and hammer the hoppers with every cast. Temperatures hover in the low 90s every day, perfect conditions for hoppers. The only problem is, Mark forgot to bring his fly pole and his fly box, and after he

Evening in a cozy, elk-hunting camp, above Rapid River

sees me catching all of these nice fish, he wants to fish, too. I take pity on him and we trade off fishing at each hole — I catch a fish, play it and release it, and then give the pole to Mark, to let him have some fun, too. All of the fishing in Loon Creek is catch and release with single barbless hooks, just like the Middle Fork.

Initially, Loon Creek Canyon looks like a typical V-shaped forested draw, but after the first couple miles, the canyon walls grow more vertical, with abrupt vertical columns of granite jutting out of the walls. Hmm, I'm thinking, this canyon is like a microcosm of the Middle Fork — it starts in an alpine forest setting, and then it opens up in the middle, and then at the end, it's all granite cliff walls like the Impassible Canyon.

On Day 2, I climb down some steep rocks along a vertical wall of granite, all covered with black moss and lichen, and fish a deep, dark section of the creek. I crank out some line and toss a yellow, brown and red Joe's Hopper in the center of the pool. Whammo! A nice cutthroat nails the fly. It feels heavy, got to be at least 18 inches.

I haul the fish out of the water to where I'm clinging to the cliff, and release it. It's a beauty, generous dashes of red on the gills, dark green sides and black spots. It matches the underwater world of the creek. I catch about 10 nice fish and decide I'd better give them a rest. Time to move on down the trail.

In a few miles, we hike into a big wide open corridor, where Loon Creek winds through a spacious meadow in long and lazy S-turns, next to the old Falconberry Ranch, a property that was purchased by the Forest Service years ago. Now, the old airstrip serves as a refuse site for the remains of cabins and

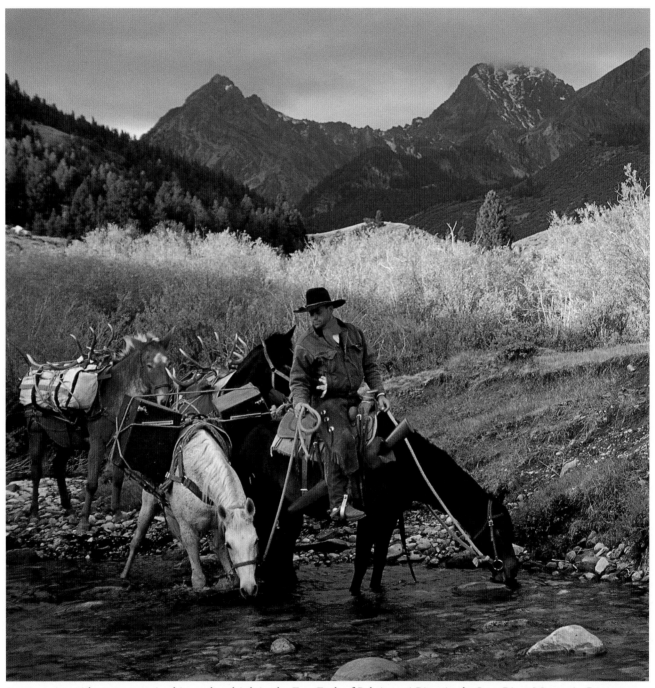

A mountain guide pauses to give his stock a drink in the East Fork of Pahsimeroi River in the Lost River Mountain Range.

debris. An old concrete tennis court stands out like a sore thumb. Below the old ranch, a giant pointy-headed peak comes into view, Falconberry Peak, on the right side of the creek. Too far away for a side hike. We cruise a few more miles down the trail to a campsite near the creek. Again, Mark and I take turns slaying the fish. Thank god I brought plenty of hoppers. Mark has snapped off four already. Gotta let those big fellas run off some steam before you bring them in.

On our final day, we have about four miles to go to Loon Creek Hot Springs, a half-mile above the Middle Fork. We take our time, do a little more fishing (just one hopper left!) and set our packs down to go soaking. It's so different to approach Loon Creek Hot Springs from the upper end — didn't even recognize the tiny trail leading to the springs.

A flight over the majestic Sawtooths

"Wow, we're here already," Mark says.

After our soak, we head down to the Middle Fork to see if we can scarf a beer from a float party. Sure enough, a group from Oregon is pulled up at Loon Creek Camp. But these guys are stingy. "We're only allowed two beers a day, so we don't have any extras," they say.

We take a swim, and then go up to the airstrip on the hill to take a nap. Our plane isn't due until evening. We hang out there until about 7:30 p.m., swapping stories with the caretaker of the Simplot Ranch. The Cessna 206 from Scott Patrick's Air Service lands on schedule.

"No screaming," the pilot says as he guns the engine for takeoff.

The Lower Loon Creek airstrip is short, and it runs downhill for takeoffs, uphill for landings. Fortunately, it isn't that hot — only in the 80s, and there's a slight breeze. The pilot has no problem clearing the ridge above the Middle Fork.

"Just kidding," he says. We enjoy a smooth flight back home, flying up the Middle Fork corridor the whole way. We feel a strong afterglow from our wonderful, secluded trip. Now, I wonder when we can plan a fishing trip on Big Creek. I hear the fishing is supposed to be just as good. . .

The Frank Church Wilderness is so enormous, the distances are so great, that horses and mules are the perfect way to get around. A number of outfitters provide summer trail rides in the Sawtooths, White Clouds, the Bighorn Crags, and the Frank Church Wilderness. During the hunting season, horses and mules are the pack animals of choice for hauling out the year's bounty, whether it's elk, deer, moose, bighorn sheep, bear or cougar.

I've met one of those guys, Stan Potts. He's one of Idaho's most successful big-game outfitters, and he likes to chase the most prized game of all, wild sheep. His clients have bagged more than 2,000 big game animals, including 71 rams, over 35-plus years. He also guides summertime fishing trips into high mountain lakes. You might say he knows the Salmon River Country better than most.

A former bull rider on the rodeo circuit, it's no stretch to say that Stan Potts is one tough fella, too.

Most of the time, a trail ride is a completely safe activity for guests and hunters. But every once in a great while, something can spook the horses and cause them to dart off the trail. For

Potts, that has happened more than once, when he was alone, with a gob of horses and mules to care for.

In his book, *The Potts Factor vs. Murphy's Law* (Stoneydale Press Publishing Co., 2001), he reels off a few tales about how things can turn sour in a hurry.

Early in the fall, Potts took eight horses and mules up the Stoddard Creek Trail to set up some elk hunting camps in his outfitting territory. He reached his North Fork camp all right, just in time to duck into the tent to avoid a hail storm. After the storm subsided, he strung together the pack string for the next stop, Colson Creek. Potts was out on the trail for about an hour when he heard a noise.

Rocky Mountain bull elk near Boundary Creek.

"I looked back and the string was coming toward me bucking and kicking and picking up speed," Potts writes. "It was slightly downhill and a narrow trail. I was riding Banjo, very responsible and agile. I was standing in the stirrups turned half around and popping the leader Susy (a 1,600-pound Percheron mare) on the nose and trying to get them slowed down. I figured I'd gotten into rattlesnakes or ground bees and at least with the bees, they come out on the fight after a few head had gone over them. We picked up a head of steam by this time. . . About then, Susy hit Banjo, spun him sideways in the trail and knocked us over the edge.

"I pitched the lead rope back at the string and dived downhill and to the right of Banjo as we took our first flip. I got stopped pretty quick. I was on my hands and knees facing downhill and remember glancing out of my left eye as I was starting to get up and seeing Banjo getting to his feet to my left and downhill. I also remember my thoughts at that moment:

'All right, we came out of this okay.'" A millisecond later, I was hit in the back by a hurtling horse, knocked face down and then they started running over me, stepping on my back, my legs, my ribs and my head. Somewhere in the wreck I remember trying to count horse feet. Let's see. Thump! Crack! Eight horses times four equals 32 feet. Ten or 12 feet have hit me. How many more can there be? Thump! Ouch! Then it got very silent."

Amazingly, Potts was still conscious. He could walk, with much pain of course. He had blood running from a gash on his head. Banjo was OK. Potts walked down the trail and found the rest of the pack string all tangled up, but no injuries. He headed back to the North Fork camp, and had to cut some trees to make it across a creek along the way. He made it to the camp, tied up the horses, and then he felt sick.

"I went into shock," he says. "Uncontrollable chills, nausea, etc. I got my sleeping bag unrolled and with all of my clothes and boots on was able to get into it and combat the shock the best I could. I lay in that bag for at least two or maybe three days."

When Potts woke up, he was so sore, he couldn't move. But the bleeding had stopped. He managed to saddle up his horses and make it back to the Stoddard trailhead. But now he's got a horse-track scar on his head.

Potts called that story "Lucky Shirt No. 1." Wonder why?

* * *

Once in a while, I get lucky and jump aboard a Cessna 206 or 210 for a breathtaking flight in the Salmon River Country. Sometimes, it's to fly into the Middle

Fork for a low-water trip. Other times, I've flown from McCall to Sun Valley, or from Boise to Salmon, or from Stanley to a backcountry location. It's a real treat, in my view, to fly over the vast wilderness because it affords a perspective that can't be acquired any other way. And it only costs about $100 for a flight that you'll never forget.

Early on a Saturday in July, I have a chance to ride on a flight across the tips of the Sawtooth Range with a pilot from Scott Patrick Air Service in Boise. Mark is shooting a second SP Air plane that flies parallel with us across the range for Scott Patrick's brochure. Thirty minutes from Boise, we fly past the headwaters of the Boise River on the west flank of the Sawtooths, and then the pilot heads around the northwest corner of the range, over the top of McGowan Peak and around the side of Merritt Peak, Williams Peak, Thompson Peak and Mt. Heyburn.

It's always fun to fly over peaks and places you've been in the high country. I peer down at all the high lakes next to the peaks, and they look like high-priced emerald jewels shining in the early morning sun. Streaks of snow still cling to the Sawtooth peaks. To see the concentration of the lakes and peaks is just baffling.

"Can you get a little closer?"

Mark wants to fly 50 feet from the other plane. Then an updraft shoots our plane higher in the sky, causing our heads to bump on the roof of the cockpit. We look over at the other plane, and it's getting bounced around in the air currents next to the mountains. My, the plane looks small next to those giant peaks. Suddenly, it isn't a magic carpet ride any longer. Glad I didn't eat breakfast.

We fly down to the end of the range, spin 180 degrees, and fly back, parallel with the other plane, while the air shoots us up and down at unpredictable times. After about 10 passes, Mark says he has shot enough film, and we can land in Stanley. I must have turned about three shades of green by then.

It's true, backcountry flying isn't for everybody. But even if I feel groggy for an hour or so after getting bucked around in a small plane, it's still worth it to see the inland sea of mountains and wilderness in Central Idaho. It reminds me how lucky I am to live in a place like this, and how many places I have yet to see, that I *must* experience.

It's a constant challenge to get away, with work and family commitments and all that, but hey, I can't think of a more worthwhile lifetime project.

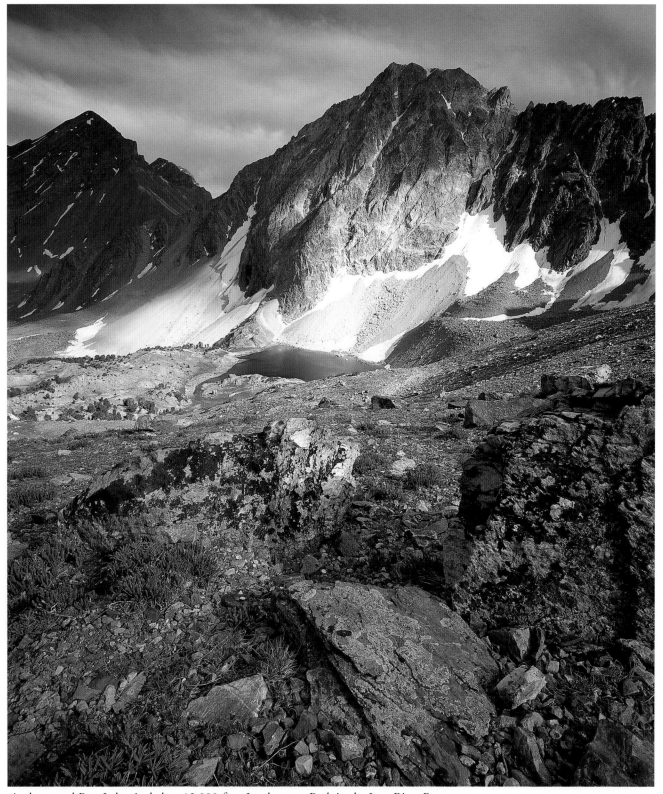

Aptly named Pass Lake sits below 12,000-foot Leatherman Peak in the Lost River Range.

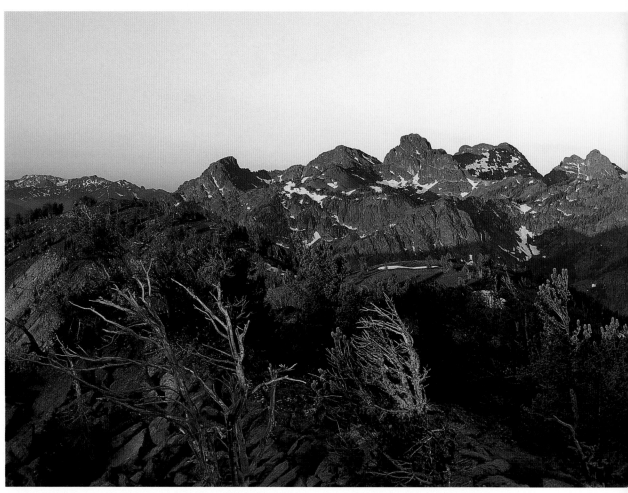

The Seven Devils, perched 7,000 feet above Hells Canyon.

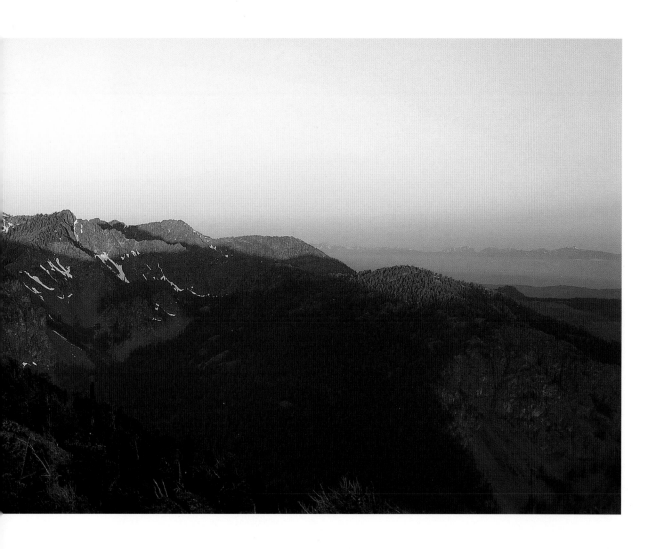

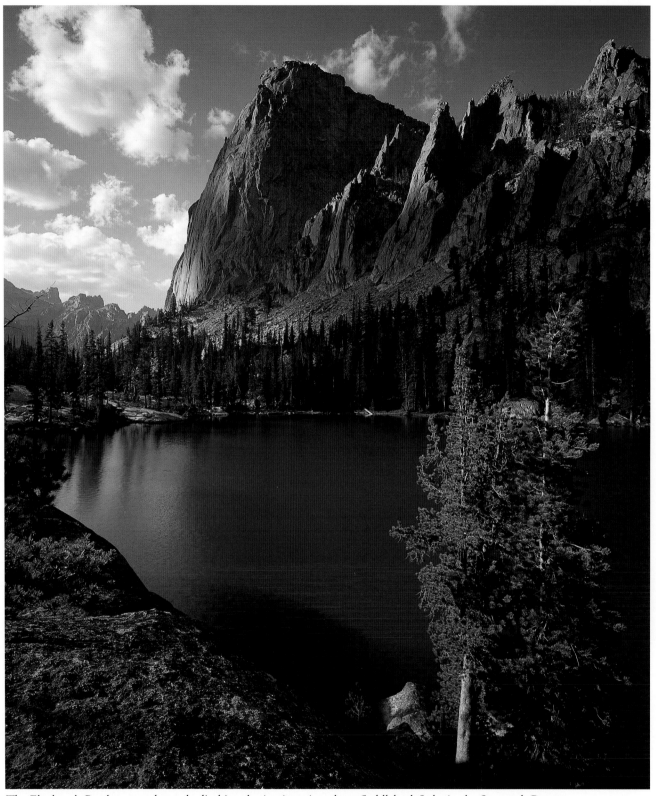

The Elephant's Perch, a popular rock-climbing destination, rises above Saddleback Lake in the Sawtooth Range.

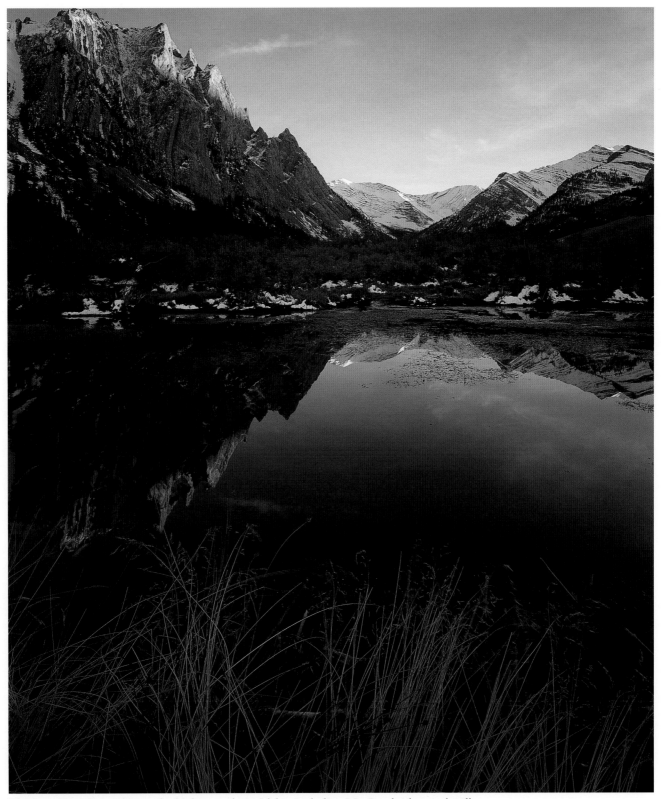

The Lost River Range boasts the highest peaks in Idaho, including Mt. Borah, the state's tallest.

Harbor Lake lies above Fish Fin Ridge in the Bighorn Crags.

Carole King – Wilderness crusader

Carole King, the singer, songwriter, from Brooklyn, New York, was drawn to the Salmon River Country in the late 1970s, seeking solace after a decade of great success. Her breakthrough album *Tapestry*, released in 1971, featuring hits like "You've Got a Friend" and "I Feel the Earth Move," sold more than 13 million copies.

"I just needed more space, and I wanted to live closer to the land, in more of a natural setting," King told me in a July 2001 interview in Stanley. Her voice is smooth and soothing, like her music.

King and a former husband lived at Burgdorf Hot Springs with her children, Molly and Levi, in the late 1970s. In the early 1980s, King purchased the Robinson Bar Ranch, the former home of Bethine Church, near Stanley. Over time, King ended up being just as passionate about protecting the environment and saving wilderness as Bethine and Senator Frank Church, D-Idaho, who led efforts to create the Sawtooth National Recreation Area and the Frank Church-River of No Return Wilderness .

Now, King is trying to take Church's legacy to the next step.

Since 1991, King has been on the board of the Missoula, Montana-based Alliance for the Wild Rockies. The Alliance backs a wilderness proposal for the Northern Rockies that would create 18.3 million acres of new wilderness, including a number of unprotected pristine lands in the Salmon River Country. The proposal includes a 1.4-million-acre Hells Canyon/Chief Joseph National Preserve in Oregon, and 1,810 miles of new wild and scenic rivers. A keystone of the proposal — the Northern Rockies Ecosystem Protection Act — is that wildlands in Idaho, Montana, and Wyoming would be connected via biologically intact corridors to provide for wildlife migration routes.

"Living here, I realized that areas were being destroyed at taxpayers expense," she says of hard-rock gold mining, overgrazing, below-cost timber sales and more.. "So not only were areas getting destroyed, but I was paying for it, and so was every other American. Once I learned about that, I wanted to protect as much as possible."

In 1997, for example, Congress subsidized the U.S.D.A. Forest Service's road-building program for timber sales to the tune of $88 million, according to the Washington Wilderness Coalition. That's what King is concerned about, taxpayers giving money to corporate timber giants to log and build roads in formerly pristine forested areas. Following timber sales, poorly maintained logging roads bleed erosion into streams, harming fish and water quality. The Forest Service has 380,000 miles of roads (eight times the size of the country's Interstate Highway System), yet it receives only 20 percent of the

funds it needs to properly maintain them and prevent erosion.

"My focus has been to make Congress aware of the need to protect wilderness ecosystems in the Northern Rockies," King says. "When we're talking about the ecosystem, we're talking about wildlife, we're talking about habitat, and we're also talking about human habitat and the human economy. So it's very important for people to realize that this is not only to protect wilderness or wildlife, but to protect it for human beings. To make an economy that's based on the ecosystem."

When NOREPA was first introduced in Congress, national environmental groups like the Sierra Club and the Wilderness Society thought it was too radical to have a chance. Now it has 111 co-sponsors.

Carole King in Stanley

"It used to be considered a wacko bill, 'what are you, crazy?'" King says. "But Clinton's Roadless Initiative made us look more moderate."

King is working with a new group called The White Cloud Council, an organization that comprises a number of national environmental groups, on a project called Parks 2 Peaks.

"What we're doing is going into towns and cities and working with the folks who are working on urban issues, and bringing them together with the folks who are working on wilderness issues. Getting people to work on these things together as a community, and involving, key word, planners, because there are urban planners, and there are people who are planning entire ecosystems so the cities are more visible, and the towns are more livable, so they can connect the urban areas to the wilderness," she says. "We want to make it a national movement."

The Alliance for the Wild Rockies backs an initiative called Yellowstone to Yukon, a concept similar to NOREPA that seeks to link bioregions in the West with wildlands in western Canada and Alaska. "We're working on biological corridors, corridors of life," King says.

"The people within the region have traditionally used it as a resource for many things, mining, ranching, timber, and recreation," she says. "The one that's renewable is recreation. There seems to be a sense by the people within the region, that the economic future of the region may lie in other directions that involve preserving the ecosystem for tourism, recreation, but also, as habitat for humans-quality of life to bring people here, and make an economy for the people who already live here in ways that are not destructive to this very precious ecosystem."

"I have pictures of my children, cross-country skiing, after we finished with our school work," she says. "They were standing in the trees, with the snow falling around us. It was just so peaceful to be out there, and it made me feel good that my kids could experience that."

And how does living in the wilderness affect her ability to write music? "It enhances it," she says, smiling. "That's really all I want to say."

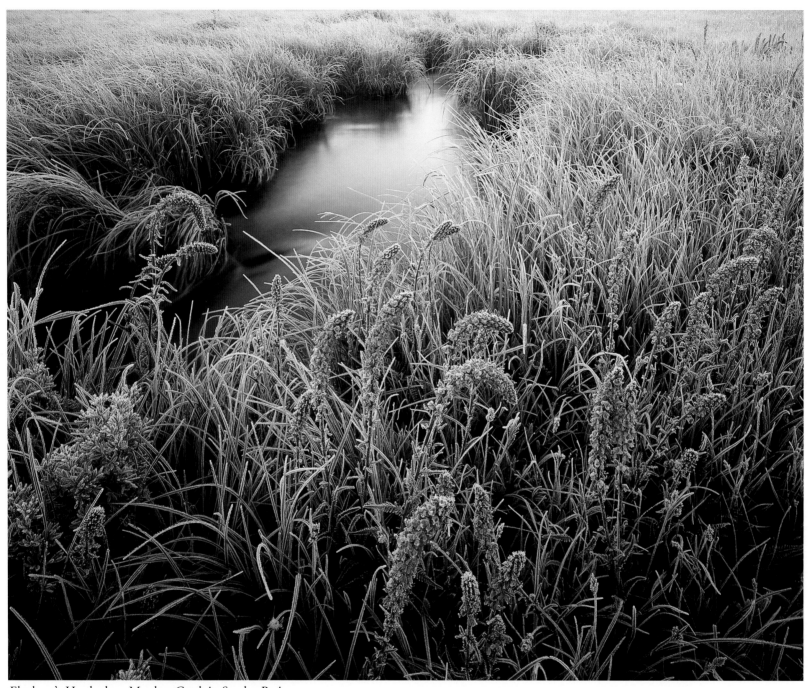

Elephant's Head adorn Meadow Creek in Stanley Basin.

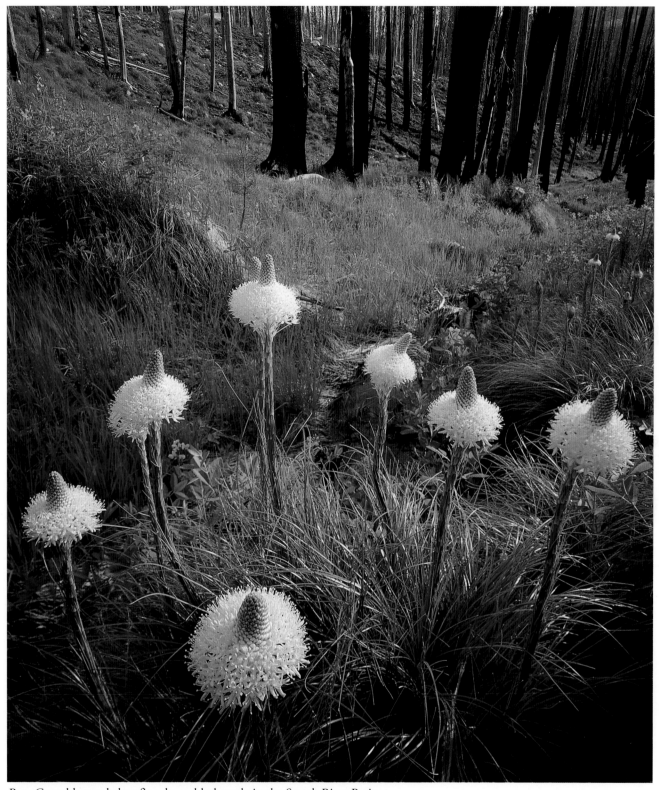

Bear Grass blooms below fire-charred lodgepole in the Secesh River Basin.

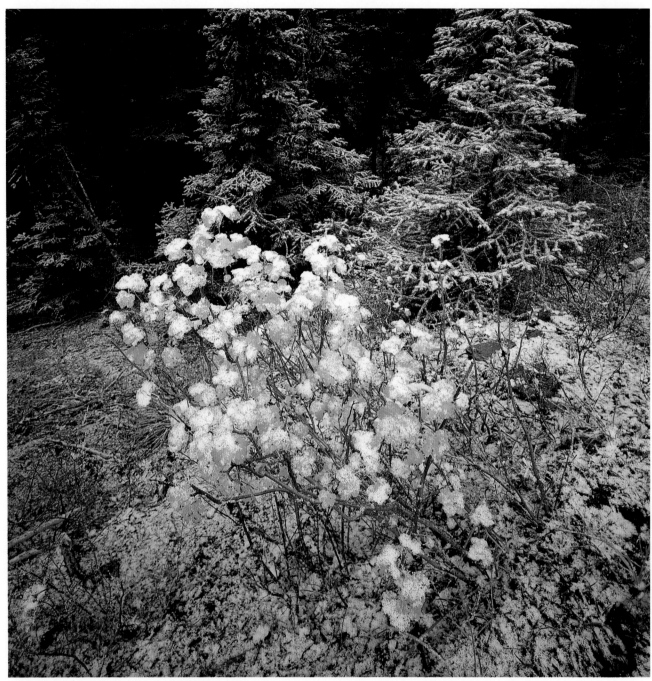

First dusting of snow in the Gospel Hump Wilderness.

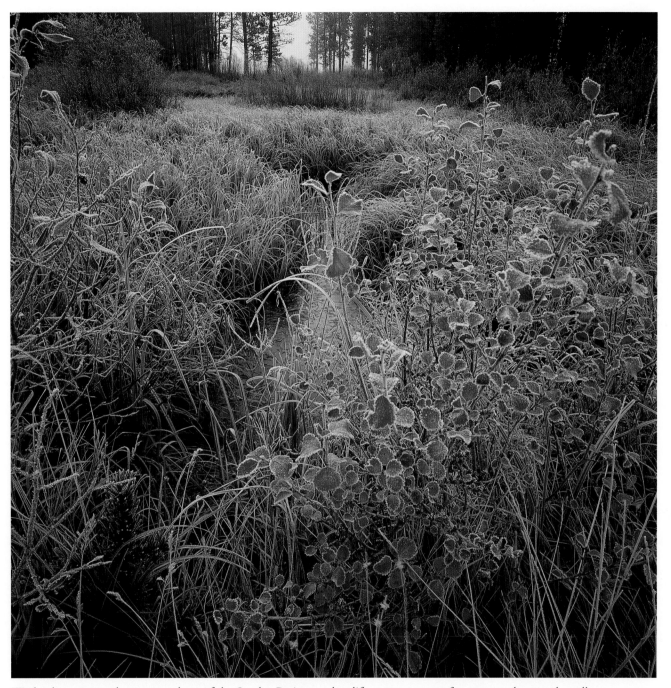

Wetlands permeate the vast meadows of the Stanley Basin — a key life-support system for creatures large and small.

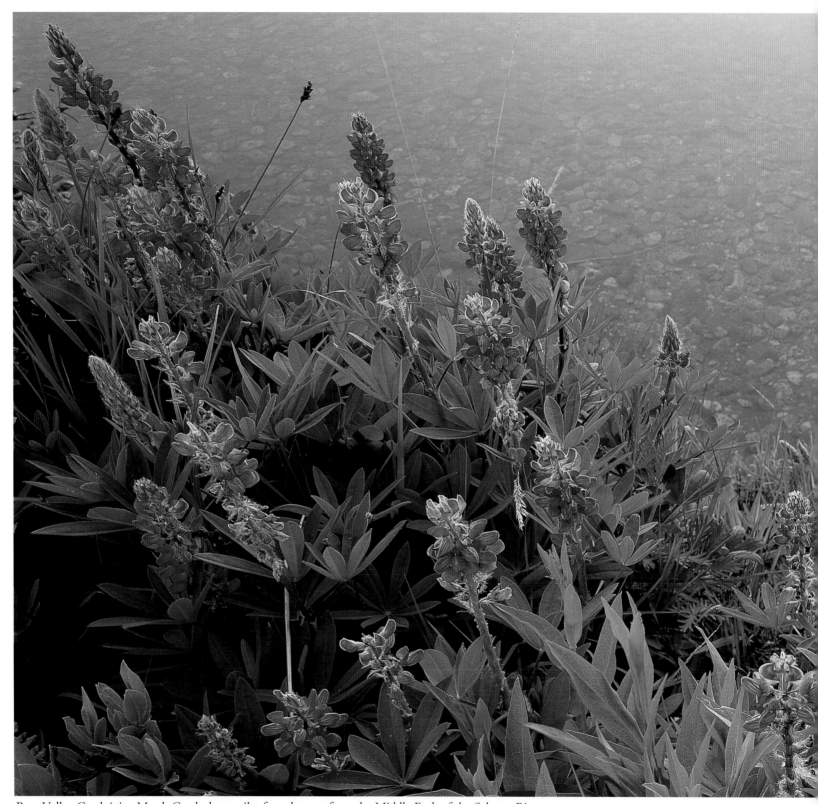

Bear Valley Creek joins Marsh Creek three miles from here to form the Middle Fork of the Salmon River.

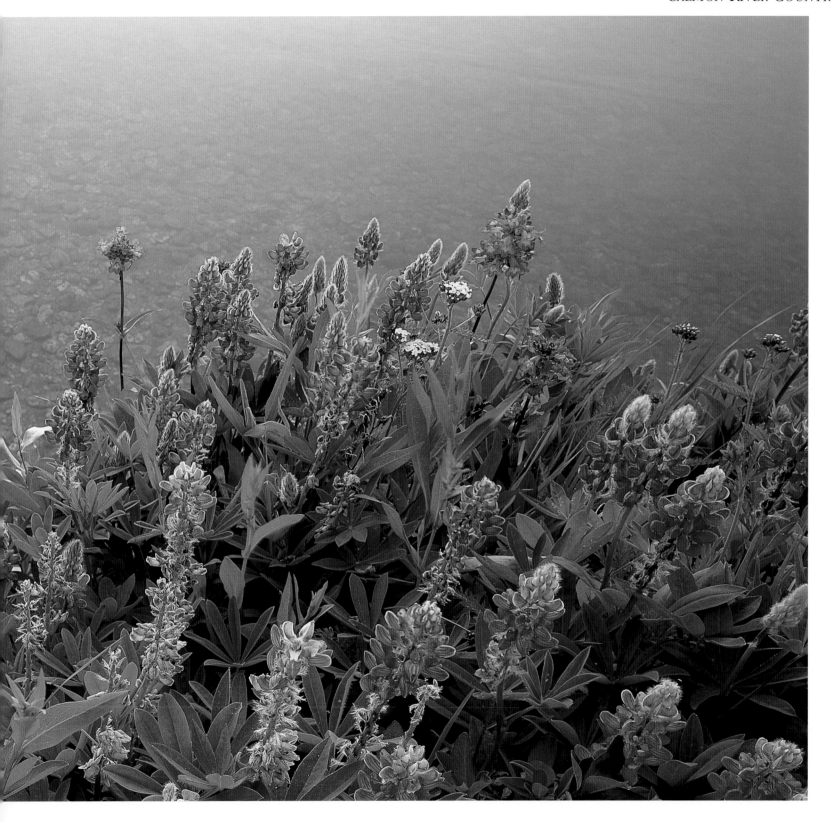

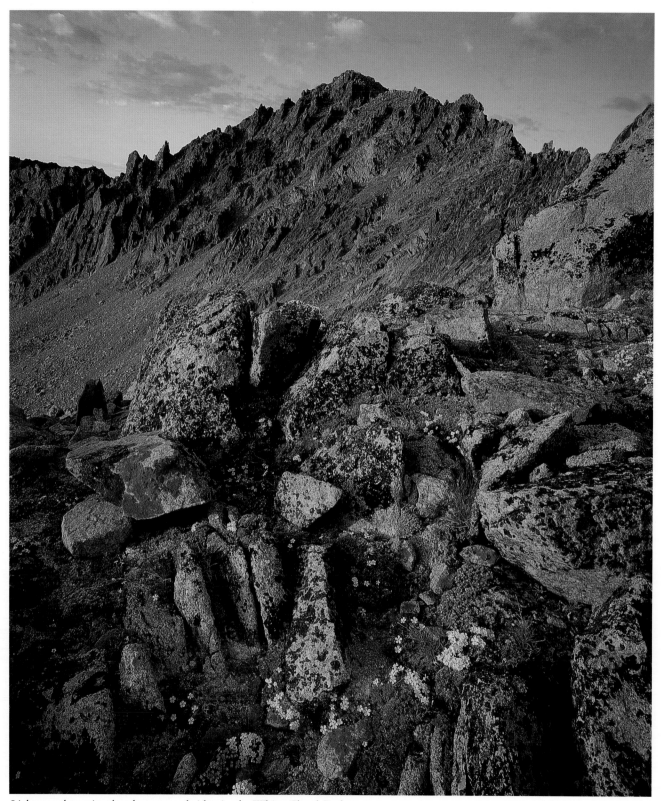

Lichen and granite sketch a serrated ridge in the White Cloud Peaks,

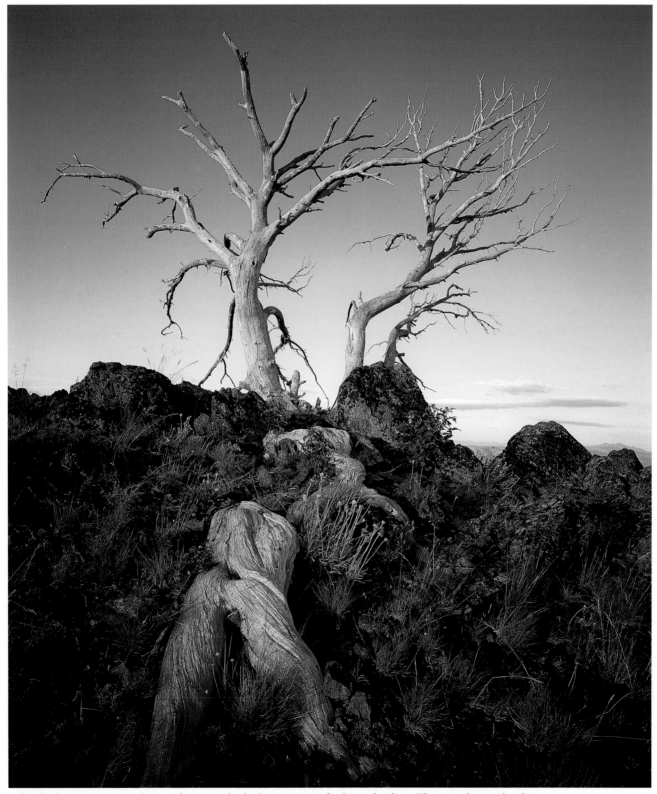

Whitebark pine tries to eek out a living on high elevation, wind-whipped ridges. This pine lost its battle.

Time

Being an Idaho native, Bruce Otto roamed the Salmon River Country as a kid, hiking, fishing, and rock-climbing in the summer, and backcountry skiing and winter-camping. In college, he studied geology. As part of his undergraduate work, he proved one of Idaho's few-surviving glaciers exists on the north face of 12,662-foot Mount Borah, the state's highest peak. Nowadays, he's a consulting exploration geologist, mapping rocks in detail throughout the world.

A lightning storm on Hatchet Lake

"I belong in these mountains," says Otto, a bearded, intelligent, and soft-spoken fellow.

To understand more about the underpinnings of the Salmon River Country, I took a trip with Otto into the dark ages of time.

Back in the Mesozoic Era, about 120 million years ago, when dinosaurs roamed the earth, we would have viewed a much different scene looking north from Galena Summit into the Salmon River Country. If we could watch a time-lapse image of the earth's crust taking form, we would see a spectacular display of fiery volcanic eruptions giving way to magma and ash rising into the sky, hundreds, if not thousands of earthquakes, and spewing lava flows across the earth's surface.

Following those events, about 40-60 million years ago, in the Tertiary period, a prolonged period of erosion occurred, "unroofing" or exposing the granites in the Idaho Batholith for the first time. Simultaneously, renewed volcanic activity, known as the Challis volcanics, in which series of explosive events shot ash and rhyolite (red-colored lava) into the sky,

occurred, decorating the canyons of the Salmon River near Challis and Salmon. During this period, the granites that would form the Sawtooth and White Cloud mountains were still capped by other sedimentary rock, and more erosion and glaciation would have to occur to expose and unroof the ranges we know today.

Several glaciation periods occurred less than 130,000 years ago. Glaciers and ice caps settled over the region, slowly down-cutting into the granite and volcanic rocks.

After the glaciers melted, the Salmon River, and its tributaries carved the beginnings of the landscape we see today, laying down gravel and sediments, the beginning layers of the soil, from which the forests and meadows formed.

"During the glaciation period there would have been a substantial amount of water that flowed through all of those basins, much more than what there is now," Otto says. "So the canyons that you see today would have been caused, in part, by a substantial amount of melt water. Imagine what the Middle Fork would look like if it had five times as much volume than it has now, even at high water. Every canyon in there would have had ice in it. The river probably carried a huge amount of ice, too."

It all started when the states of Washington and Oregon were islands in the Pacific Ocean, and the west side of Montana and eastern Idaho formed the Pacific Coast. The islands were on the move, heading on a collision course with the coast. When the collision occurred, the oceanic crust burrowed underneath the continental crust, sending sedimentary rocks several kilometers into the earth's crust. That action caused temperatures to rise, the rocks to remelt, and the resulting

red-hot magma to shoot out of now-extinct volcanoes in central Idaho.

Underneath the volcanoes, the beginnings of the Idaho Batholith, a massive granitic formation that runs from points north of Boise through the central core of the Salmon River Country to Lolo Pass, Montana, was beginning to rise. A contrast in density between the molten granite and surrounding rocks would have driven the granite upward out of the earth and into the sky. Many earthquakes would have accelerated the rise of granite rocks, and caused adjacent valleys to descend.

"Substantial amounts of pressure, small little zones of molten material will coalesce, and as they get bigger and bigger, there's a greater density contrast and these things will try to seek their own density level," Otto says. "That's what drives them upward."

In real time, the mountains would rise by several centimeters a year, sometimes more, sometimes less.

"It's like if you take a piece of ice in the bathtub, and you pull it down underneath the surface and let it go, it will rise to the top," Otto says. "That's what granite does."

Before the granites began to rise to substantial heights, Central Idaho may have been a flat gravel-covered plain for miles in all directions, if you believe a theory espoused by C. P. Ross, a geologist who worked in the middle part of the 20th century. Ross believed that a zone called the "Idaho Peneplain" dominated the region now occupied by the Idaho Batholith. As any mountain climber knows, it's uncanny how all of the tallest peaks in the batholithic region are in the range of 10,000 feet.

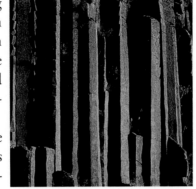

Columbia River basalt columns. Green Canyon, Salmon River

"When you climb a 10,000-foot peak, you're struck by the fact that there isn't hardly a peak in all of Central Idaho that isn't over 10,000 feet, plus or minus a few hundred," Otto says. "I don't know that Ross' theory is widely accepted, but I certainly haven't read anything to refute it, and from my observations, I certainly believe it."

When Otto has prospected in the Panther Creek area, west of Salmon, he's found big gravel bars on the tops of ridges and peaks, the remnants of the Idaho Peneplain.

As the granites rose, and the valleys fell, old rock that once covered the top of the granites eroded away, Otto says. Eventually, the granites dominated the sky in the batholith region. At least two different glacial periods — one 70,000 to 130,000 years ago, and another just 10,000 years ago — did a final polishing act on the peaks, canyons and valleys.

When the glaciers melted, the creeks and rivers would have carried a massive amount of floodwater, further carving the mile-deep canyons of the Middle Fork Salmon, Main Salmon and South Fork Salmon.

"The shape of the land we see today was there tens of millions of years ago, and the glaciers certainly modified it some, but the shape of the landscape is ultimately defined by the structural geology, by the distribution of faults, folds and the areas of uplift," Otto says. "If you have a stream that meanders through a large valley, and then that valley, for whatever geologic reason gets uplifted, the stream will keep pace with the uplift by downcutting through the rock and form a very deep incised canyon."

That's at least a partial explanation for how the great

canyons of the Salmon River Country were formed, he says, and it's the same type of phenomenon that formed the great canyons of the Colorado Plateau. "One of the best examples of that downcutting action is the goosenecks of the San Juan River," he says. "That was a meandering stream, the whole area got uplifted, and those meander scars just went straight down."

Granite rock is not easily subject to erosion, so that's why the Sawtooths have more than 40 peaks over 10,000 feet high, in a relatively compact area, just 20 miles wide by 35 miles long. Same goes for the ocean of peaks in the Frank Church-River of No Return Wilderness, in the batholith zone.

The Salmon River leaves the Sawtooth Valley, and begins a meandering course toward Challis. It leaves the batholith zone near the Yankee Fork area and enters a complex region that passes through much older sedimentary rocks and the more recent Challis volcanic zone. A series of volcanic explosions about 40 to 55 million years ago spewed molten basalt, ash and rhyolite into the air, leaving a wondrous display of basalt and rhyolite vertical columns and ash deposits that line the Salmon River between the areas near Challis and Salmon.

Three distinct mountain ranges in the east side of the Salmon River Country, the Lost River Range, Lemhi Range and Beaverhead Range, contain much older sedimentary rocks — mainly limestone, sandstone, shale and dolomite — from the Paleozoic and Protoerozoic Ages, between 250 million years ago to more than 1.4 billion years ago. All three ranges run parallel to each other, trending in a diagonal direction, southeast to northwest. They were formed in a similar manner that created many parts of the Rocky Mountains in the Basin and Range province of the western United States.

The geology of the Salmon River Country set the stage for creating a unique mountain and river complex that's unlike any other in North America — the longest dam-free river and the largest chunk of wild country in the lower 48. If it weren't for the continuous blocks of granite and other hard rock, government engineers might have found a way to bore a railroad or a highway through the canyon. The sheer ruggedness of the Salmon River canyon, and the prohibitive expense of such projects, combined with the canyon's reputation as the River of No Return, forced the engineers to retreat.

The same holds true of the heart of the Frank Church-River of No Return Wilderness, the Sawtooth Wilderness and the White Cloud Peaks Primitive Area. The mountains were too disheveled and the canyons were too deep for loggers to penetrate the region. Only the miners found a way through in a few instances, such as Thunder Mountain. Today, only one active mine remains, the Thompson Creek Molybdenum mine near Clayton.

It's nice to learn about rocks from people like Otto because now I often find myself staring at the rocks, cliffs, peaks and canyons in the Salmon River Country and thinking about those geologic events that occurred so many years ago. It's yet another humbling aspect of this place that makes me feel small.

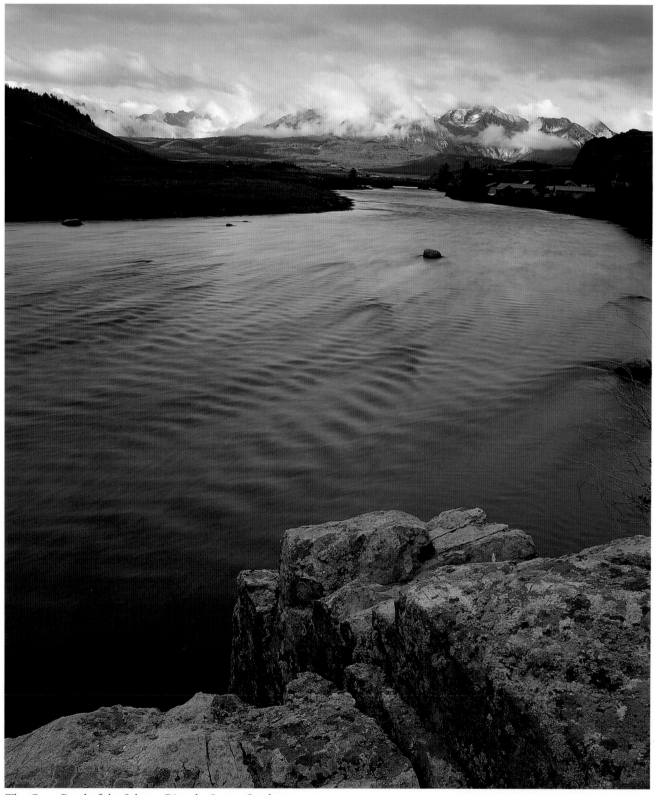

The Great Bend of the Salmon River by Lower Stanley.

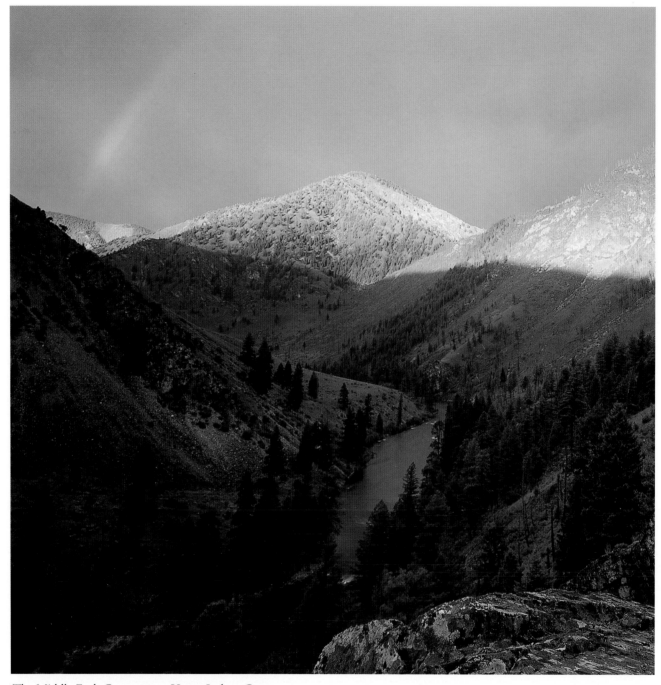

The Middle Fork Canyon near Upper Jackass Camp.

The River

It's about 7:30 on a July morning at Upper Jackass Camp on the Middle Fork of the Salmon River. I'm just beginning to wake up. Lying in my summer-weight sleeping bag on the beach — about 10 feet from the river's edge — I can hear the steady trickle of pure water rolling by. In the pale blue morning sky, I watch a group of puffy clouds grow pink and purple. At this particular moment, the clouds closely resemble a herd of buffalo, lined up in perfect symmetrical formation.

With that good omen above me, I crawl out of my bag. The sun begins to peer over a high grassy ridge and beams a rich golden light across our spacious campsite, lined with stately ponderosa pine trees. Instead of heading over to the "kitchen," I reach for my fly rod and wander over to my 14-foot raft. Standing on the captain's seat, I begin the rhythmic flow of the fly-casting routine, stripping out green floating line, as I watch the first hatch of tiny flies dance on top of the water's surface. My brown, green, and white green-bodied royal humpy drifts along in the slow current for a moment on a flat, glassy column of water.

Bam! A fine Middle Fork native cutthroat does a barrel roll on the surface, nailing the fly on the way down, and I set the hook. I reel in the fella, and he's a fighter, a 14-incher, with a dash of crimson red on the gills, and black spots on his green sides. Good morning.

Oh, how wonderful it feels to be here on the lovely Middle Fork, one of the finest wilderness rivers in the world. It's day three of an eight-day trip, and I can feel myself falling in tune with the wilderness spirit. Today, we'll fish 15 miles of gorgeous turquoise pools, floating deeper into the mile-deep canyon, stop at Whitey Cox Hot Springs for lunch, and then camp at Loon Creek tonight.

At Loon Creek, we'll hike a half-mile to the best hot springs on the river, a deep rectangular pool with 103-degree water. It might be quite a party tonight at the springs. I've soaked with more than 25 naked, spirited people in total darkness in the past.

Next to the Grand Canyon, the Middle Fork is the most cherished wilderness river trip in the United States. But there's a quota on how many people can go each year. In 2001, more than 31,900 kayakers, rafters, and canoeists from throughout the United States applied for only 311 permits to run the Middle Fork on their own. The same year, 50 outfitters from Idaho, California, Montana, Oregon, Washington, and Utah took more than 10,000 people from all over the world down the Middle Fork and The Main. Both rivers have hosted a long list of celebrities including the Kennedys, President Carter, Tom Brokaw, Bill Cosby, Woody Harrelson, Susan Sarandon, Tim Robbins, and Sun Valley resident Jamie Lee Curtis.

The Main Salmon, the longest free-flowing river (dam-free) in the contiguous 48 states, runs for 475 miles from Stanley to Hells Canyon. It's well-behaved, predictable, and mostly mellow, except in peak flows. In the spring, snowmelt pours off the mountains and swells the Salmon River to huge levels, up to 100,000 cubic feet per second, the highest anywhere in the United States outside of Alaska. At this time of year, a few diehards run the whole thing for a month of wilderness river bliss.

"The Main," as locals call it, breaks down into five popular day trips starting from Stanley, Salmon, North Fork, and Riggins. The 80-mile wilderness section of The Main is considered the finest week-long family river trip in the nation, even a good candidate for grandma and grandpa. The white-

water on The Main ranks primarily Class 3 on a scale of 1-6, from July to September. That makes the trip safe and stress-free for folks who are just dipping their toes into the wilderness whitewater experience for the first time. I took my mom and my dad down The Main when they were in their early 60s. It was the first time they'd camped outdoors since they were teen-agers, and they both had a grand time. The rafts carry all the gear, and large iced coolers, Dutch ovens, and charcoal make it possible to eat better than you would at home.

On a typical day on the Main Salmon in high season, there might be four commercial parties and three or four private trips rigging and launching their boats — a maximum of eight parties total.

Outfitters have honed river trips to a science. A bus picks up the guests at a hotel in Salmon,

Hard shell kayaking

Idaho, and drives them to the Main Salmon launch site at Corn Creek. There, the guides are waiting, with all of the boats packed and ready to go. All the customers have been given dry bags the night before to pack their goods for a week. The guides tuck away the dry bags, fit the guests with life jackets, deliver a safety talk, and decide who's going to ride where. Some people like to paddle, some like to sit and enjoy the scenery, and some like to paddle an inflatable kayak.

Launch days are still stressful for me as a private boater because I'm usually in charge of parceling out the gear, and there's always more stuff than willing takers.

"Hey Jim, can you take the firepan?"

"No way, I'm already carrying too much weight."

"Hey Greg, can you take the lawn chairs?"

"No way, give them to Jim."

"Who's going to take the porta-potty?"

Dead-silence. No one ever wants to take the potty, because once it lands on your boat, it always stays on your boat, and, you know, it may not smell so sweet by Day 5.

Once you're on the river, all of the logistics fade away, quickly overtaken by the deep timbered canyon of The Main, the second-deepest gorge in North America, next to its cousin, Hells Canyon. At this time of year, it's a relaxing trip, with no worries about people getting flipped in rapids. It's a time to enjoy the scenery, take side hikes, soak up history, fish the side canyons, play volleyball on sandy beaches, eat delectable Dutch oven meals and enjoy great company.

I went down the Main Salmon with many of the top outfitters and about 25 paying guests in 1990, during the Idaho Centennial Float, organized by the Idaho Outfitters and Guides Association.

The pros cooked all the meals and did the dishes. They told stories around the fire. Plus, we got to watch the guides take turns steering an authentic wooden scow through the rapids when the waves were still big and fun. They ran the boat with two big wooden sweeps, one on the bow and one on the stern.

As always, I kept a copy of *River of No Return* by Cort Conley and Johnny Carrey close at hand to follow the history of the canyon, mile by mile, as we proceeded downriver. The Main is rich with history — a number of early gold-miners, hermits and mountain men set up homesteads and mining operations in the canyon in the late 1800s and early 1900s. A few of them were successful, and a number of their cabins remain in place today.

We stayed the first night on a nice beach near Lantz Bar, about 11 eleven miles downriver from Corn Creek. After supper, we went down the river trail to visit Frank Lantz's place. Lantz lived on the Salmon River for 45 years, beginning in 1925. An employee of the Forest Service, he built more than 200 miles of fine backcountry trail. He also planted an orchard, which always means trouble with black bears raiding the fruit. The cabin is fairly new, compared to most. It was rebuilt after his old cabin burned down in 1964. Volunteers for the U.S. Forest Service stay at the cabin during the summer, and they're always happy to give a tour of the place.

Lantz died in 1971, at his place on the Salmon River. His body was flown to Hamilton, Montana, and transported to Corvallis, Oregon, so he could be buried beside his wife, Jessie. "If success is measured by the size of the hole a man leaves after he dies, then Frank B. Lantz's death left a Carlsbad along the River of No Return," Carrey and Conley said.

Evidence of the canyon's early residents abounds in the Salmon River canyon — you can stop to view pictographs on the rocks, old cabins, and the old wire telephone line that connected backcountry residents along the Main Salmon.

At Campbells Ferry you can pull over on river right, and hike to the Jim Moore Place, an old homestead on the National Register of Historic Places, or walk across the pack bridge to Campbell's Ferry, former home of Frances Wisner, a popular gal who wrote a regular column about Salmon River happenings for the Idaho Free Press in Grangeville.

On the Centennial Float, we camped at Rhett Creek, near it's namesake ancient cabin. I met two daughters of the Wolfe family who spent several years living on the Salmon River while being home-schooled by their mother, Rheo. She took care of seven children, actually, and taught them how to play the violin.

Fly fishing for steelhead, Salmon River near Whitewater Ranch.

A black and white photograph of the family appeared in *Look* magazine, the epitome of country living. But the Lewiston school board filed a criminal complaint against Rheo Wolfe that fizzled out over time, claiming she was contributing to the delinquency of minors.

Below Rhett Creek, there are many more historical highlights — the old cabin of Polly Bemis, a former Chinese slave who became one of the most beloved women to live on the Salmon River, Buckskin Bill's place at Fivemile Creek, and Mackay Bar, which operates a general store, a restaurant, and a number of guest cabins.

When soaking up the history in a wilderness setting, it's remarkable how little has changed since the first pioneers tried to settle on the river. That makes it easier to imagine how life might have been like for them. Standing on the river bar near Rhett Creek, you can almost hear the children's violins playing in the wind.

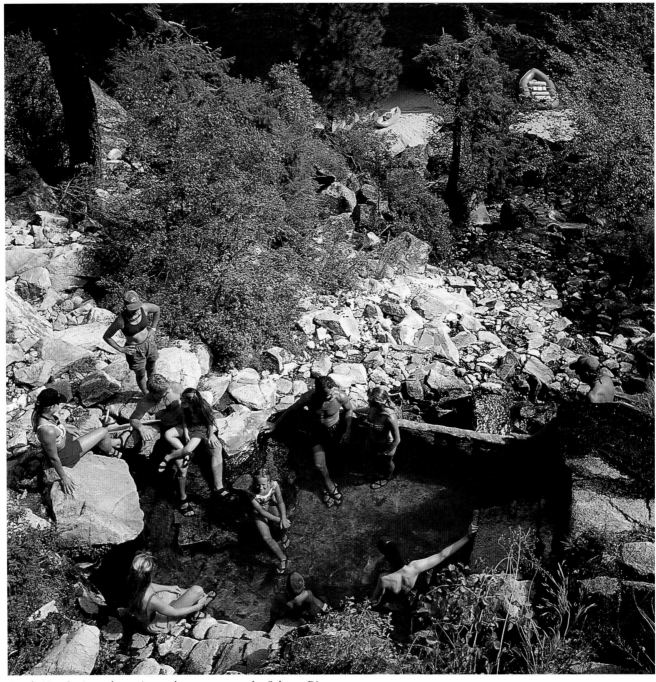

Barth Hot Springs always is a welcome stop on the Salmon River.

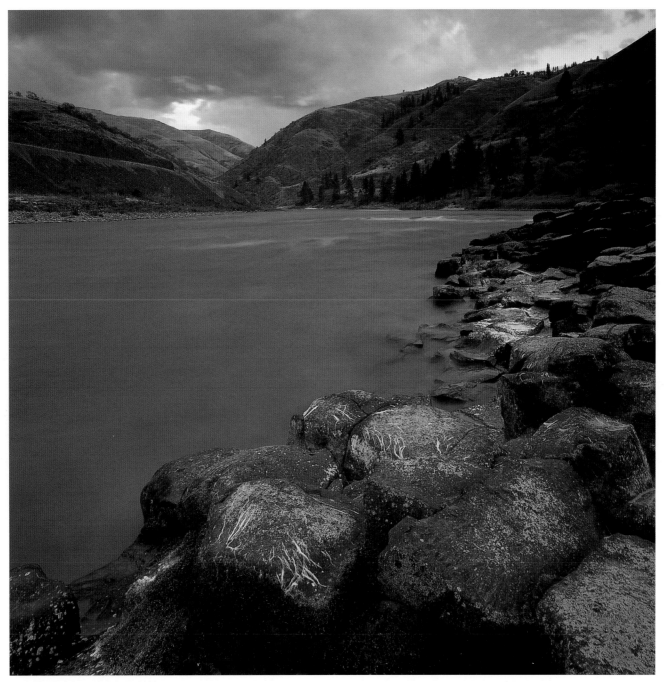

Pine Bar, Lower Salmon River.

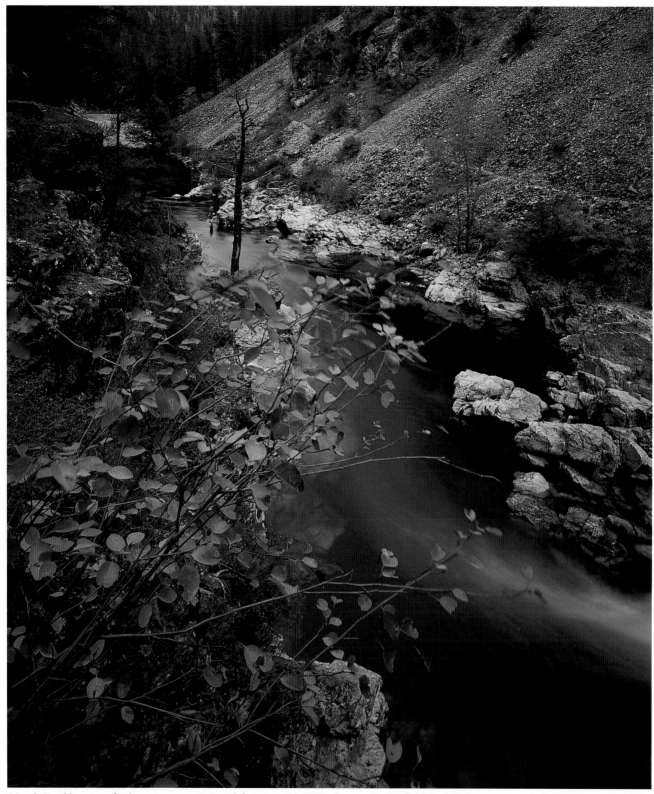

Pistol Creek's many feeder streams are named for guns, like Winchester, Springfield and Colt.

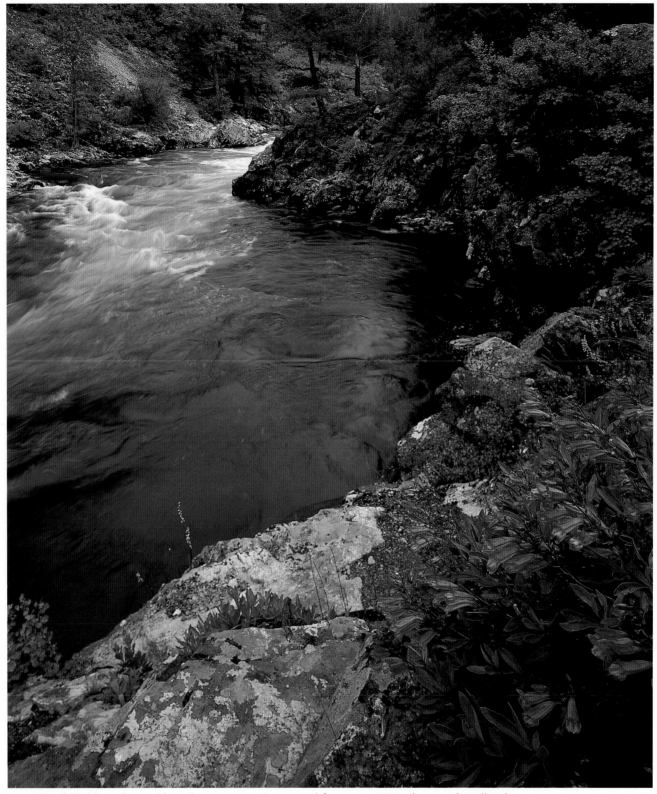

Deep Pistol Creek pools provide an important resting ground for ocean-going salmon and steelhead.

Cliffside Rapid, Middle Fork of the Salmon River.

Salmon River Profile

Sheila Mills — Dutch Oven Queen

Back in the early 1970s, when most Salmon River rats were men and the women guides tried to act like men — you know, the tobacco-chewing thing and a few other choice, unmentionable macho things — a young, attractive woman with curly brown hair trotted into the life of David Mills.

Her name was Sheila. She had just moved to Pocatello, Idaho, following a divorce, and she had two young children. Dave saw this woman whose blue eyes shined like moonbeams talking to a mutual friend in the cafeteria at Idaho State University, and ambled over to meet her.

"I didn't think she'd be interested in me, but I thought, what the hell?" he says. "All of these guys were drooling over her, and I knew that if I didn't act fast, she'd be gone."

Dave was the director of ISU's Outdoor Program at the time, and thus, was known as a big-time outdoor stud on campus. He wore a thick Grizzly Adams-style brown beard, and he talked a million miles a minute. He asked Sheila out on a date — a winter-camping trip in Sun Valley. Forget about the candlelight dinner. Let's see if she can survive the rough stuff.

She said, "Sure!"

Sheila had a hankering for adventure. She also had a heck of a lot more class than any other woman Dave had ever met. In the spring, Dave took Sheila on her first river trip, a weeklong journey on the Salmon River. On the first night, the ISU lads cooked up a forty-mile stew in the Dutch oven. The recipe: throw a bunch of spuds, onions, ground chuck, and chicken broth into the pot, and let it cook for an hour while everyone parties around the campfire.

By the end of the trip, Sheila realized that she could make anything in a Dutch oven that she cooked in a conventional oven. Just put the right number of charcoal briquettes on the top and the bottom, and *presto* you've got an oven. On the next trip, Sheila prepared the meals. "I can do a lot more interesting stuff than forty-mile stew!" she told Dave.

He was smart enough to let her take over the cooking chores on the next river trip. Sheila already had a ton of experience in the kitchen. She knew how to make all kinds of stuff from scratch — bread, cheesecake, casseroles, soups, salad dressings, you name it. She was an anti-war protestor, environmentalist, and civil-rights activist in Oregon and Montana, and thus, she was going through a "vegetarian phase" at the time.

In 1978, Dave and Sheila launched their own outfitting business, Rocky Mountain River Tours. As the former ISU Outdoor Program director, Dave knew all of the rivers, and how to run the trips from a logistical standpoint. His gift for gab helped attract customers. But he also had a secret weapon: Sheila's cooking. It was leap years ahead of anything that had been served on the river before.

First, they had to get rid of the old guides. Most of

them were ready to quit anyway. "The guides were saying, we're not going to work for you, all of this new-fangled cooking is too much work," Dave says. "The guides looked at food as just another thing to get out of the way so you could go smoke some dope or go for a hike. There was no pride in the cooking at all."

The late '70s were a busy time for Dave and Sheila. They ran trips on the Main Salmon, Middle Fork, Lower Salmon, Hells Canyon, and the Snake River Birds of Prey Area. The logistics of buying food and outfitting all of the equipment for five rivers at once were a nightmare. Sheila handled all of the shopping, guided a boat, and cared for her two kids, Kevin, 11, and Adrian, 6, who went on all the trips with her.

Sheila Mills, Dutch oven innovator

When they weren't on a river trip, the Mills family and their guides lived in a small one-bedroom shack in Salmon. "There was no privacy whatsoever," Sheila says. "I don't know how I did it."

After three seasons of running around with their hair on fire, the duo decided to scale back, and focus on running high-quality trips on the Middle Fork, their favorite river, with a special emphasis on Sheila's Dutch oven menu.

In the midst of the chaos, Sheila cranked out her first cookbook, *Dutch Oven Kettle Cuisine,* self-published in 1980.

"David made me do it," she says. "I don't like to draw attention to myself. But he thought it would be good for our business. And it was. We started publicizing our cookbook, and getting our name out there so it was well-known, and made a transition to taking more couples and families and people who were interested in quality and were willing to pay for it."

Nowadays, Rocky Mountain River Tours is one of the most upscale outfitting businesses on the Middle Fork. But many other outfitters on both the Middle Fork and The Main have developed their own gourmet menus, too. Today's river guests expect to be fed like queens and kings, no matter what company is taking them downriver. Beyond food, outfitters have created specialty offerings such as drift boat fishing, business meetings on the river, and instruction in arts and crafts.

Sheila continues to add new recipes to her menu each river season. She makes unique casseroles like Tomato Onion Tart served with crabcakes rolled in potato chips. Then she bowls everyone over with Devil's Tooth Cheesecake for dessert. All of the food is fresh. Sheila pays gardeners in Salmon to grow fresh lettuce and an off-beat sausage-maker in Venice Beach, Calif., who provides orange garlic cumin chicken and duck sausage for her Salmon River Lasagna. She buys fine wine from the Boise Co-Op.

Sheila penned a second Dutch oven cookbook in 1990, and then a third book, *The Outdoor Dutch Oven Cookbook,* in 1997. With more than 200 recipes, the book is on sale in popular bookstores across the nation.

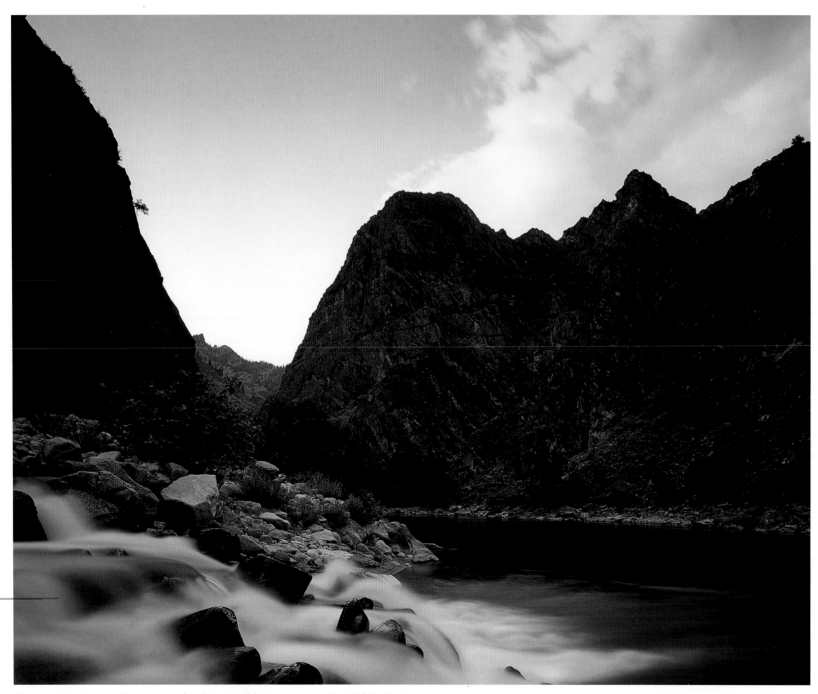

Papoose Creek roars down steep-faced Impassible Canyon on the Middle Fork.

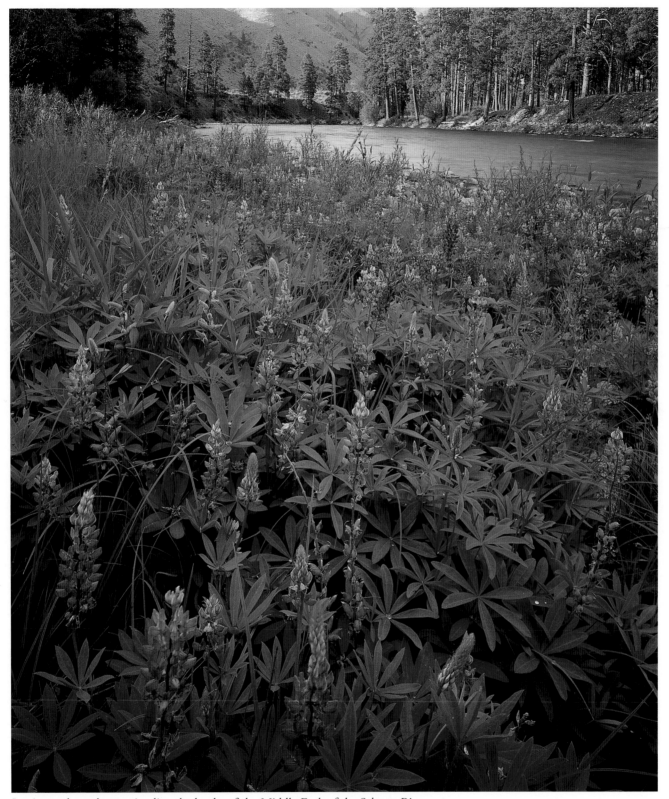

Lupine and ponderosa pine line the banks of the Middle Fork of the Salmon River.

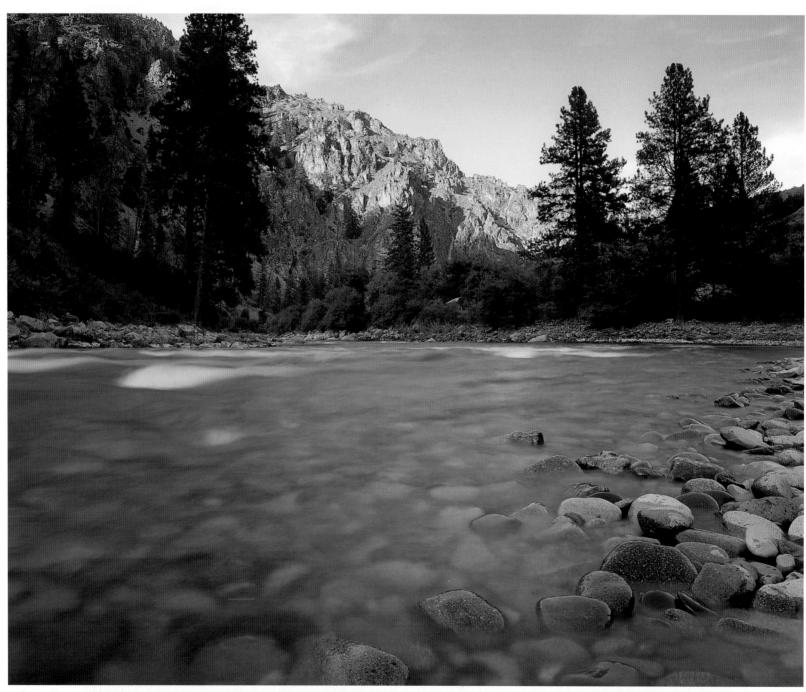

Salmon River cobble dominates the scene at Funston Camp, Middle Fork.

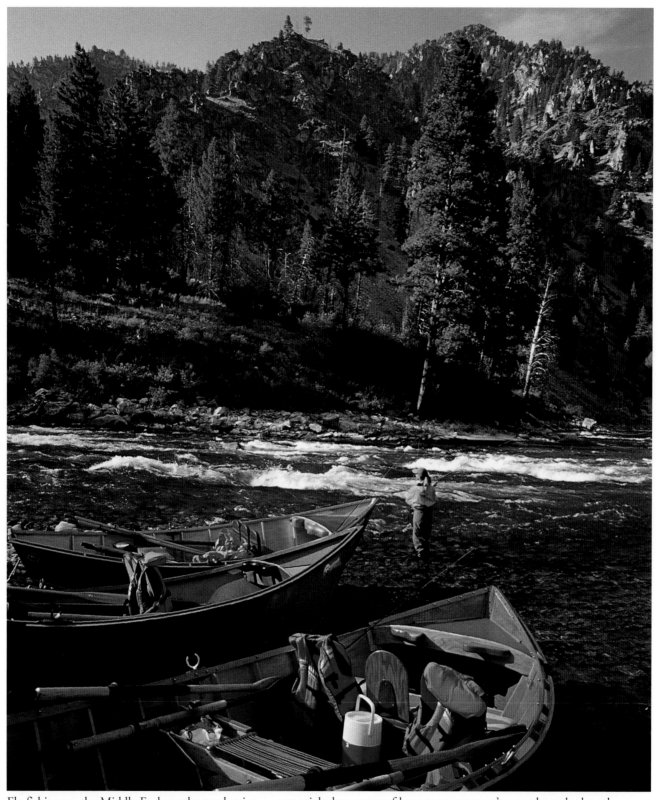

Fly fishing on the Middle Fork can be productive — you might lose count of how many cuts you've caught and released.

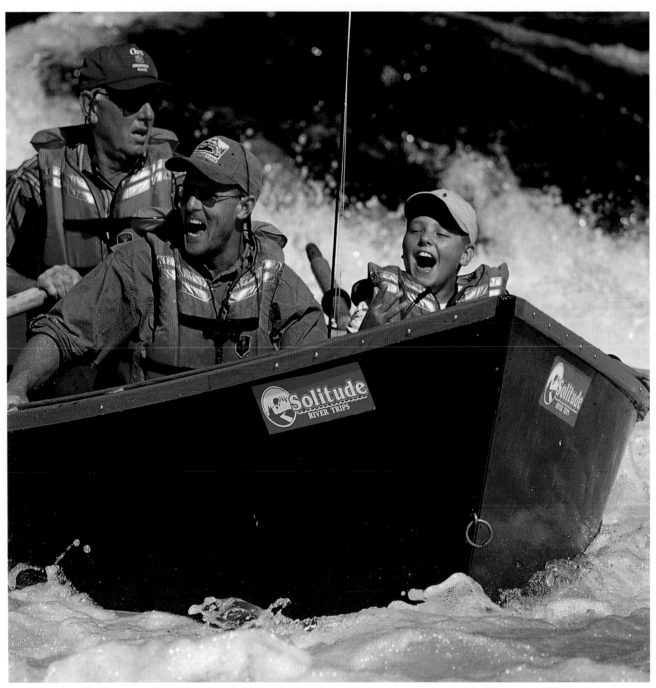

Tappan Falls creates a perfect Kodak moment for Middle Fork guests.

Floating and fishing

In the fall, a deep quiet descends on the Main Salmon. All the tourists are gone, and no one is left except a smattering of die-hard steelhead anglers. Then, it's easy to imagine how still and lonely it might have been for the old-timers who

Boise Bar, Salmon River

lived on the river before it was "discovered" in the 1960s and 1970s.

Mark Lisk and I seized an opportunity to go steelhead fishing in the fall of 2000 with Salmon outfitter Mark Troy, owner of Idaho Adventures, and longtime river guide Jerry Myers, owner of Big Boat Idaho. Myers and Troy had prepared the most luxurious trip possible, by arranging for us to stay in a different lodge each night for five days. I yearned to catch a monster steelhead. We were fortunate to be taking the trip during one of the biggest runs on record.

Below Hancock Rapids, about 72 miles west of North Fork, the Main Salmon slows to walking speed as it threads through a series of deep teal-green pools. We're on day two of our trip, and I'm starting to realize that I've casted a silver-and-blue spoon several hundred times into river, and have yet to catch a fish.

"Swing your lures through here," says Troy, as he tugs at the oars of his 16-foot Riken raft. A veteran Salmon River whitewater, hunting and fishing guide, Troy knows that this particular area is fishy. "We've caught some in here before," he says.

Some 25 casts later, Troy holds the raft in an eddy on river left, pulling on the oars upstream, just above a small riffle. I cast to the far right bank of the river and feel my 3/4-ounce

Wobbler trot along a uniform bed of gravel as it pendulums across the current. Suddenly, the lure seems to be snagged. I rip the rod straight back, and it doesn't move.

"What's going on?" Troy asks.

"I'm not sure," I say. And then we watch a big wild steelhead take the line 40 yards upstream and leap out of the water.

"Fish on!" Troy yells with glee.

I play the fish for about five minutes, allowing it to make multiple runs away from the boat. It even leaps a second time. I pay careful attention to keep my rod tip up because we had trimmed the treble hook to one, and the barb was pinched. Finally, we got a close look at a fine 14-pound 32-inch female wild steelhead — the largest fish caught on our boat, so far.

Steelhead fishing requires a boatload of patience, tenacity and persistence. It might take 100 casts or more to catch one fish. But when you hook into a fine one, you forget the frustration. By the end of the second day, our party has caught seven fish between four guys. I catch another leaping wild fish just minutes later in the same pool, and another one less than an hour later. What a treat, I thought, to catch multiple fish (all big and wild) in one day.

Bill Stimmel, an Orlando, Florida-based angler who has caught marlin and other large fish in the ocean, agrees. "This was the best fishing trip I've ever been on," he says. "I came out here to Idaho feeling haggard, stressed out to the max, and then I stepped out into the wilderness, and I'm catching big fish I've never seen before. Those fish are great fighters, and they're really strong."

By the third night, when our group stayed at Allison Ranch,

a grinning Stimmel asked: "Can it get any better than this?"

During steelhead season, most anglers fish from the bank between North Fork and Stanley, and Lucile and Riggins, or they take a jet boat trip to a choice hole somewhere in Central Idaho. We were enjoying the crème de la crème of the steelhead fishing experience. We not only could fish every patch of water on the way downriver, being on a raft, we also got to stay in heated quarters every night, after a cold day on the water.

By the end of our trip, we had caught 22 fish between four guys. I caught and released seven wild steelhead, including a big fish just minutes before we reached Mackay Bar, the end of the trip.

Jerry and Mack, steelhead fever

We're back on the Middle Fork, day seven of an eight-day trip. Today, we're looking forward to a sight-seeing triple-header — Veil Cave, Tombstone (pictographs) and a wedding anniversary celebration in the Grotto by Parrot's Cabin.

By now, everyone is in the wilderness spirit. The Impassible Canyon makes your jaw drop every time you round a bend and see a new vista. We pull up to Veil Cave and hike up a faint goat trail on the steep talus slope to the cave. It's a huge carved-out alcove, somewhat reminiscent of Redwall Cavern on the Grand Canyon, except here, there is a tiny creek that flows over the top of the cave, sending a trickle of water into a small pool at the bottom of the cave. My buddy Rick goes down to stand in the pool, and he starts to whoop and howl, getting splashed by the waterfall.

I venture down to take a look, and it is magical. Directly under the spray of water, I look up and watch individual drops of water float down through the sky in slow motion, like snowflakes. After you've been in the wilderness for a week, you can really enjoy moments like this at a deep, intimate level.

Next, we float downriver to Tombstone on river left for lunch. It's hot, in the 90s, and the dry grass crunches under our river sandals as we climb toward the vertical blond-colored rock. At the base of the rock, a wide variety of red Indian pictographs can be seen all over the rock face. Small animals. People shooting bows and arrows. Large animals with antlers. Horses. Some of the rock has chipped away, destroying the art work, but much of it is still preserved. Definitely worth the stop.

In the early afternoon, we drift to Parrot's Cabin, and hike to the Grotto. It was here, 11 years earlier, in July 1990, that I took my friends Greg and Jan to see the Grotto for the first time. They liked the spot so much that the next year, they got married in the Grotto. The ceremony was attended by 18 members of the river party. This year was the 10-year anniversary of the wedding, and many of the same folks were on our trip. I had actually drawn a Middle Fork permit through the lottery, so the stars were aligned in our favor.

For the ceremony, we have two bottles of champagne, a few words from Greg and Jan, and a few toasts from their friends. And then the skies open up and rain pours down on us. It's almost 90 degrees out anyway, so who cares? Actually, the temperature drops 20 degrees in five minutes, and the men without shirts are suddenly shivering.

But the rain instantly increases the flow of a small waterfall that flows over the top of the Grotto, and the impressive booming snarl of the thunder gives me chills.

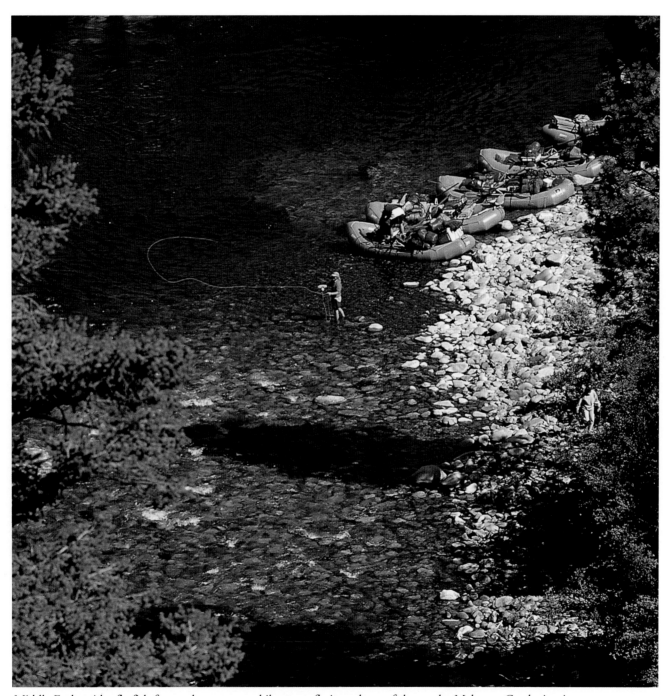

Middle Fork guides fly fish for cutthroat trout while guests fly in and out of the nearby Mahoney Creek airstrip.

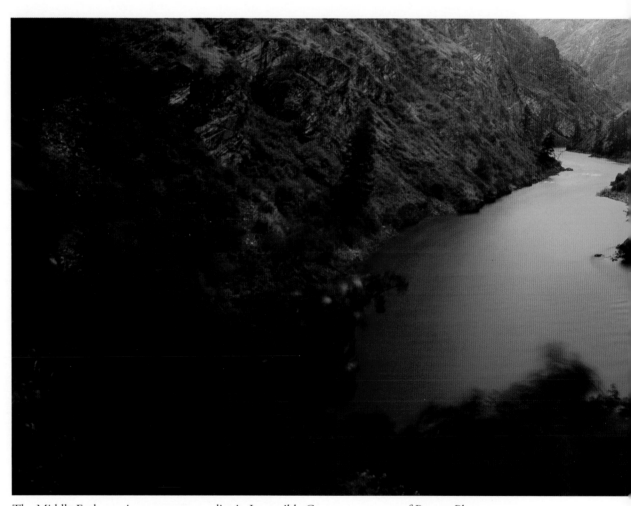

The Middle Fork acquires a new personality in Impassible Canyon, upstream of Parrots Placer.

Salmon River Profile
Red Woods – Captain Gentleman

Red Woods

Red Woods pulls up in a large eddy at the confluence of the mighty Salmon and Snake rivers, in the heart of Hells Canyon, in his 28-foot, 600-horsepower twin-engine Bentz aluminum jet boat. It's more than 7,000 vertical feet from here to the top of 9,393-foot He Devil, the highest point in the Seven Devils Wilderness.

Woods is picking up a group of my friends after a five-day "cast and blast" October adventure on the Lower Salmon Gorge. It's an annual affair in which we chase chukars, fish for steelhead, and generally have a good time regardless.

At the mouth of the Salmon, you either have to float down to Heller Bar in Lewiston for another 20 miles or so, or you can jet boat 30 miles to Pittsburg Landing, where our vehicles were shuttled from the launch point at Hammer Creek, downstream from Riggins. We opted for the jet boat option to cut a day off of our trip and get back to our jobs in Boise. In his big, powerful boat, Woods can take all 10 of us, plus three rafts and a kayak to Pittsburg.

A baby-faced guy with a twinkle in his blue eyes, Woods wears a red Dutch Harbor hat from Alaska, along with a flannel shirt, jean jacket, jeans and boots. He's a native of Mesa, Idaho, a town near Council in western Idaho that died in the Great Depression. He's a typical boat guide from Riggins in the respect that he's just as comfortable handling a saddle horse or a tractor as he is behind the wheel of a powerful jet boat.

Woods worked in the woods as a logger right out of high school, he cowboyed for 10 years at the Circle C Ranch, and he ran a pack string for the Payette National Forest for 20 years, shuttling around fire crews, maintaining trails and performing a variety of tasks for the government.

He met his wife, Karen, at the Circle C. She was the cook. They settled on a place about 10 miles up the Little Salmon from Riggins and raised three boys. In 1976, Woods decided that he'd try to build a jet boat outfitting service, shuttling customers to guest ranches, taking people fishing for trout, bass, steelhead, Chinook, and sturgeon, and shuttling floaters wherever they wanted to go on the Main Salmon and Hells Canyon.

A jet boat's capability of driving upstream or downstream also has found favor with whitewater boating parties that wish to cut their trips short or get shuttled back to the launch instead of shuttling a vehicle to the takeout. "That business is really coming on strong," Woods says. "I

shuttle a lot of floaters from Vinegar Creek to Corn Creek on the Main Salmon."

Running a jet boat is a tricky deal. Drivers have to understand how to run the rapids, both upstream and downstream. In the middle of big drops, the waves can be enormous. Skilled jet boaters learn how to sneak around the big hazards by following a tight line through the froth, usually on the edges. In the big rapids, sometimes they have to aim right into the throat of giant glassy waves.

"I've hit some rocks and had some wrecks, but I always have gotten to the

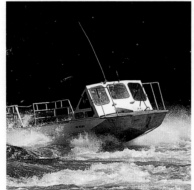
Red Woods' 28-foot, 600 horsepower Bentz jet boat

bank," Woods says with a smile.

On the Main Salmon, Woods hates to run Growler and Elkhorn at low water most of all. "Those two scare me," he says.

Woods figures he's going to stay in the jet boating business as long as his health allows him. "I've been here since '59," he says. "I've got two rivers right close to get out on, and a lot of mountains to get out on real close, too. All of that has always meant more to me than the money."

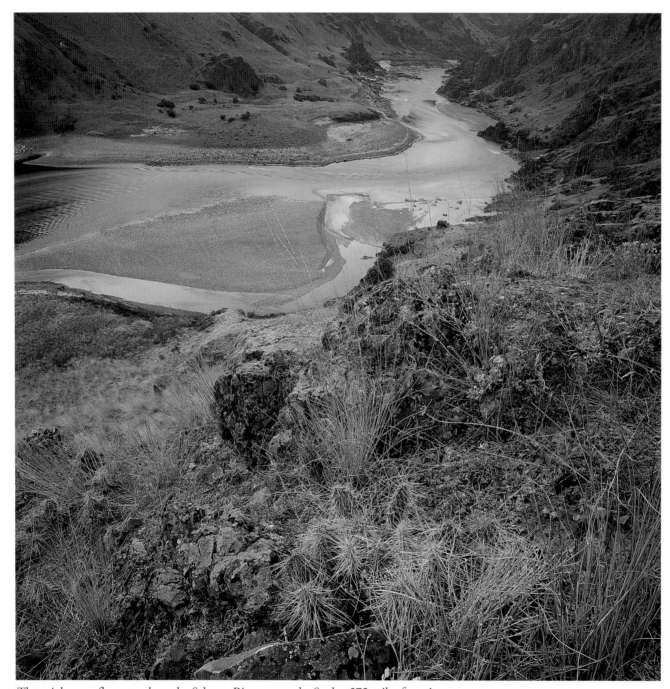

The mighty confluence, where the Salmon River meets the Snake, 575 miles from its source.

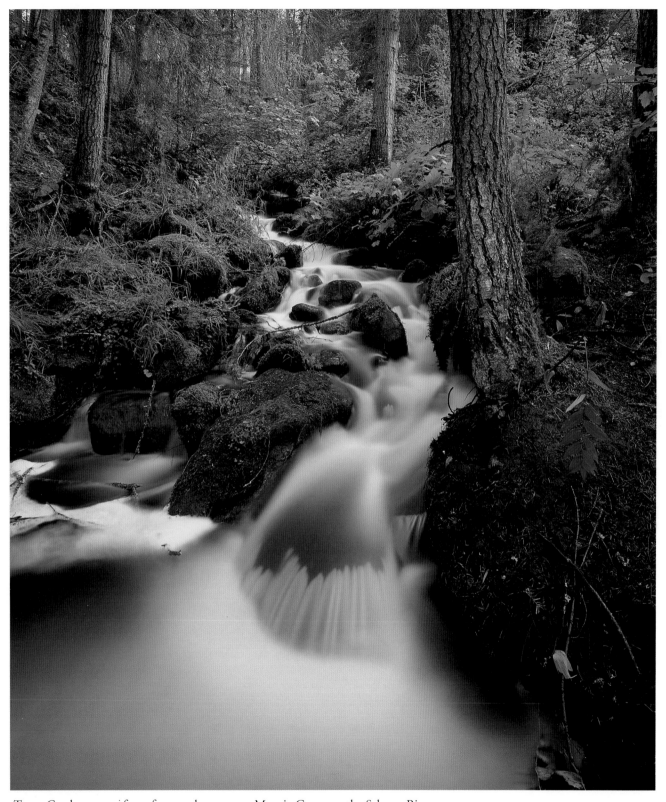

Trout Creek emerges from ferns and moss near Magpie Camp on the Salmon River.

Salmon River Profile
Les Bechdel — River Legend

In the mid-1980s, Les Bechdel and his wife, Susan, went trolling for a new river experience. They found their own personal Shangri-La on the Middle Fork of the Salmon River.

A former national kayak champion and world-championship team member, Bechdel was vice president of operations for the Nantahala Outdoor Center in North Carolina at the time. As the author of *River Rescue*, the definitive book on river rescue techniques, Bechdel was a whitewater guru who could have gone just about anywhere he wanted, and thrived.

He looked at Alaska, Idaho, and California, and, fortunately, he picked McCall, Idaho.

"Our first Middle Fork trip was magical, even though the engine in our vehicle blew up in St. Louis on the drive across the country," he says. "In those days, Idaho was almost like going back to the 1960s. The rivers were really clean and pure, and there wasn't very much use. We decided that we had to get a Middle Fork permit and start a new business in Idaho."

Initially, Bechdel got a Main Salmon permit for the 78-mile Corn Creek to Vinegar Creek wilderness section, and three years later, he bought a Middle Fork permit as well. In contrast to the rest of the outfitters, Bechdel mainly caters to kayakers and canoeists. People from throughout the nation come for a chance to paddle with a legend.

It's a family business. Les manages the river company and provides instruction on the river, while Susan handles a fair share of the phone calls and customer contacts. Their kids, Laura, 21, and Max, 19, are experienced whitewater river guides. Max is a world-class kayaker who is following in his father's footsteps, trying to win competitions around the world.

Beyond the outfitting business, Bechdel offers river rescue courses each spring on the Payette and Salmon Rivers in Idaho, and elsewhere. He teaches how to rescue swimmers in swift whitewater situations, how to free rafts, kayaks, and canoes from wrap situations (where boats get stuck and swamped on rocks) and how to rescue people from horrible predicaments in which they're pinned above or underneath the river on rocks.

Before Bechdel's book came out, no one had ever laid out the rescue techniques in a step-by-step methodical manner. Private boaters and outfitters took notice.

So far, *River Rescue*, which is illustrated in an entertaining way by Slim Ray, has sold more than 110,000 copies. "It's incredibly gratifying," he says. "I've gotten so much out of rivers, it's nice to give something back."

One of Bechdel's techniques for yanking boats off of rocks in a wrap situation is called the Z-drag. Boaters learn how to use stout ropes (static lines) in combination with, slings, carabiners and pulleys to increase the force from a 2:1 margin to 27:1 to get the craft free. It's a whitewater science that separates the men from the boys, you might say.

"The physics of the Z-drag have been around since the pyramids," Bechdel says, playing down the credit he's received for pioneering the technique. "After a kayaker drowned back East in 1980, I saw a connection between rope skills for rock-climbing and river rescue. That spring, I started teaching the techniques for guide training, and then I started to teach courses throughout the United States and Canada.

"Then it dawned on me that I've got enough material for a book. The rest is history."

In McCall, one of the best river towns in the USA, Bechdel lives close to day trips on the well-respected Payette River, the Little Salmon, the Secesh, and the East Fork of the Salmon River, all Class 4 to Class 5 paddling adventures for advanced to expert boaters.

"Oh, it's world-class," he says. "Within two hours, there's over 20 days trips you could do, everything from Class 1 to Class 6. It's one of the reasons we located here, the variety of rivers, and the lack of traffic. We just have a hard time deciding where we're going to go on any given day."

The South Fork Salmon River is Bechdel's favorite wilderness river, just over the hill from McCall.

Les Bechdel

"The South Fork is truly the river that I love," he says. "This is my own personal river. It's one of the rare whitewater rivers in the United States that doesn't have a commercial presence, and it probably won't ever have one. Here, you can just enjoy the river and the wilderness, the curvature of the wave, the roots of why I love to run rivers in the first place."

Since the late 1990s, kayaking has seen a bit of a revolution in terms of kayak design for downriver and freestyle use. Kayaks are shorter, and more maneuverable than ever before. They're built for all kinds of rodeo moves — endos, cartwheels, spins, you name it.

Bechdel has been staying current, using new boats, but paddling with his children pushes his limits, he says. Both Max and Laura kayak on Class 5 rivers, just like their dad has done for years, but Les is in his 50s now, and he's ready to dial it down a little, while his kids are still finding their limits.

"My kids are so much like me, it's scary," Bechdel says. "I don't know how much longer I'll be able to keep up with them."

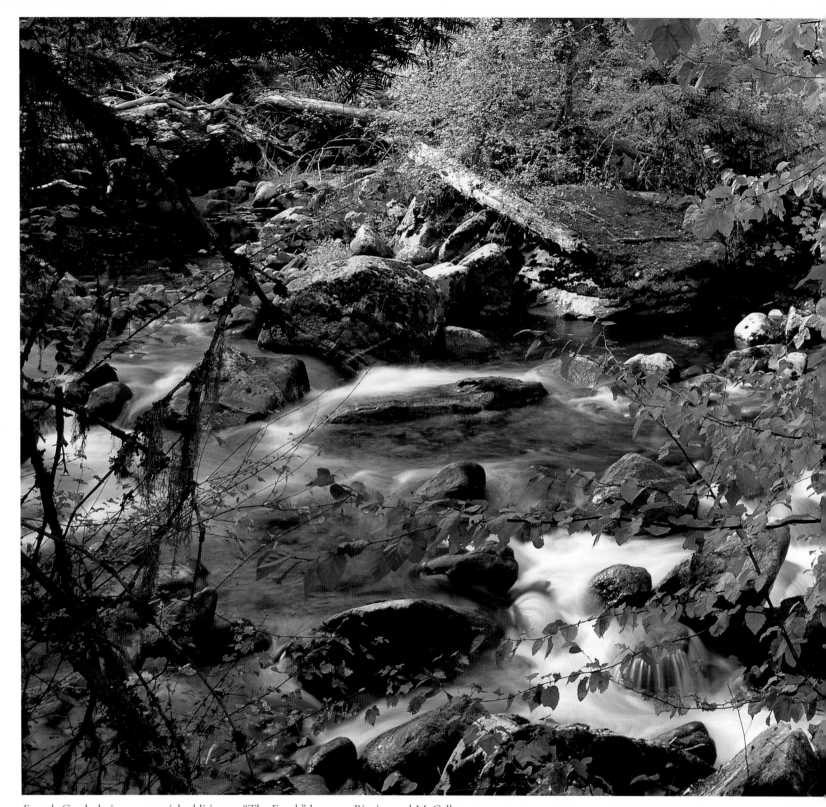

French Creek drains a potential addition to "The Frank" between Riggins and McCall.

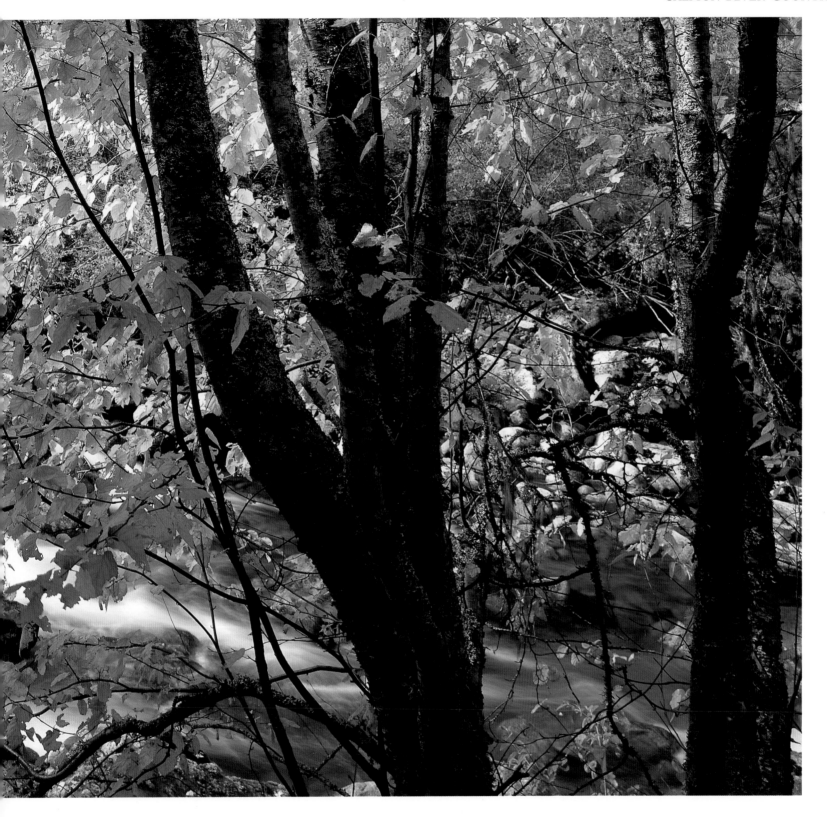

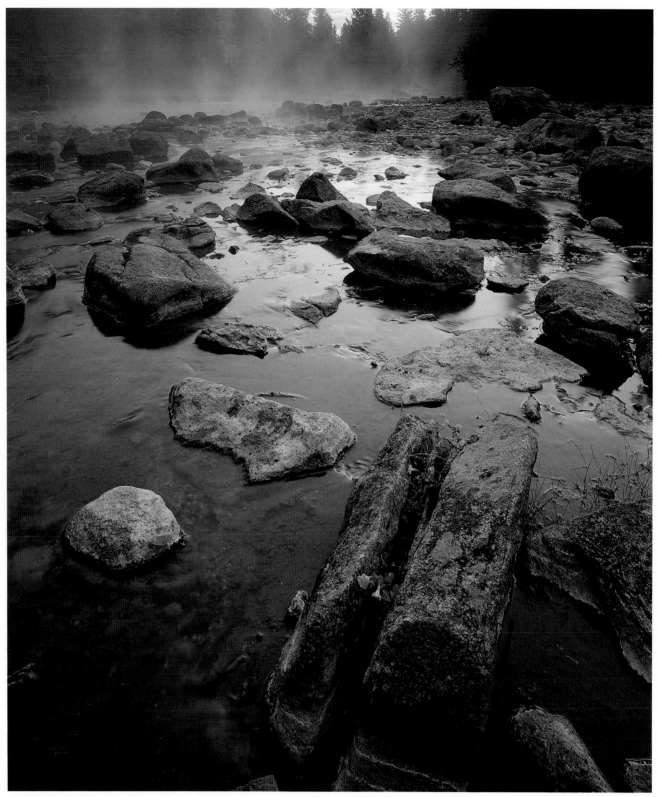

Sheepeater Hot Springs attracts late-night dippers and curious mountain goats.

Lily pads in a tranquil section of the Little Salmon belie the steep waterfalls looming ahead.

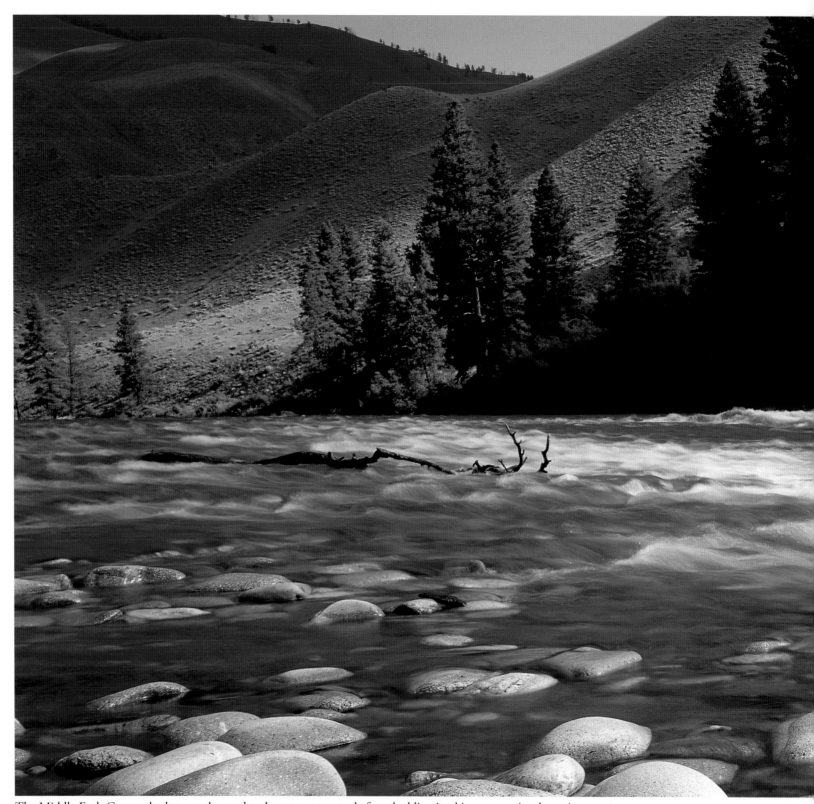

The Middle Fork Canyon harkens to the sagebrush-steppe ecotype, before shedding its skin once again, downriver.

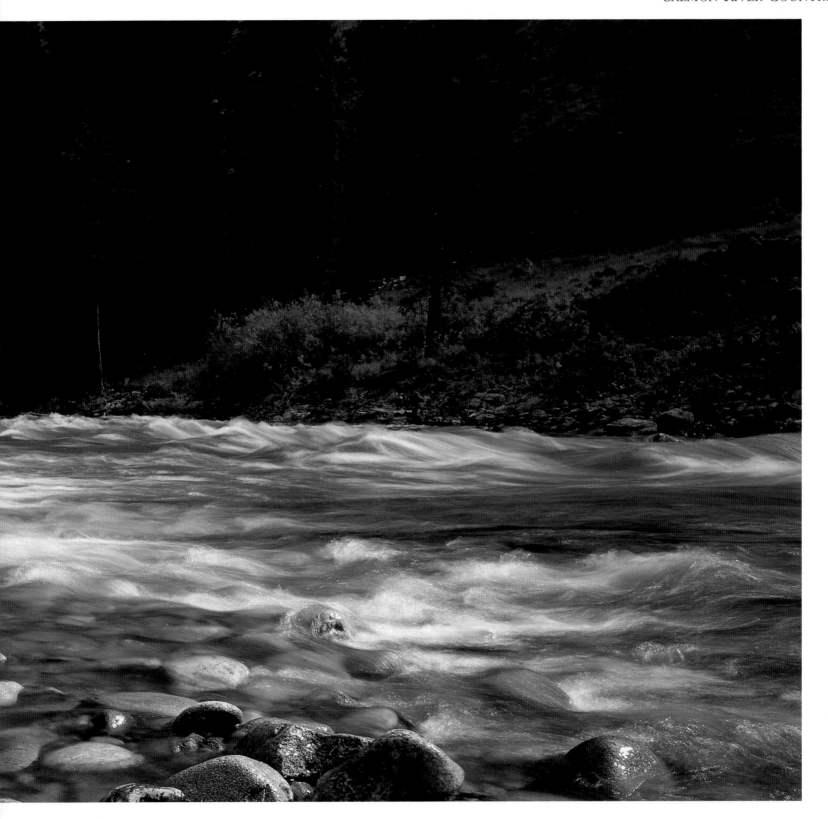

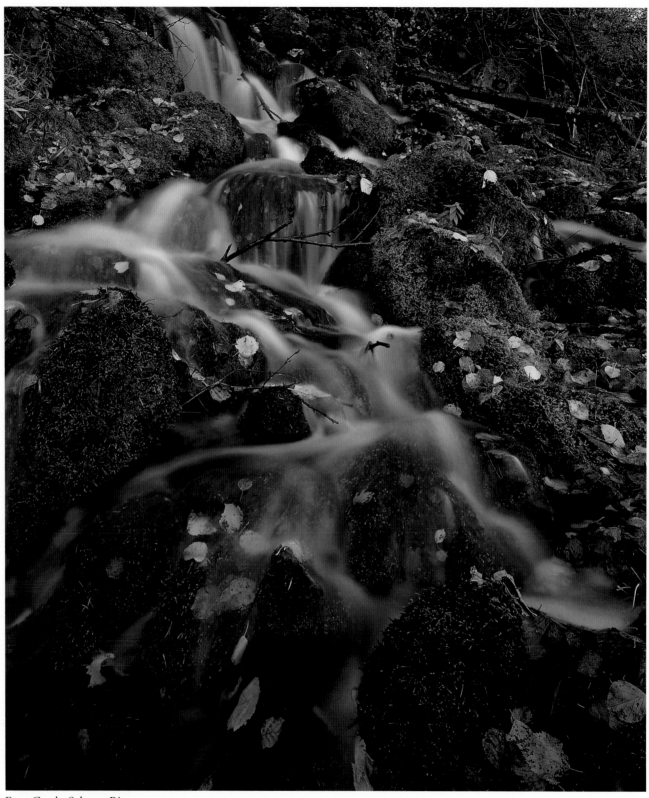

Fern Creek, Salmon River.

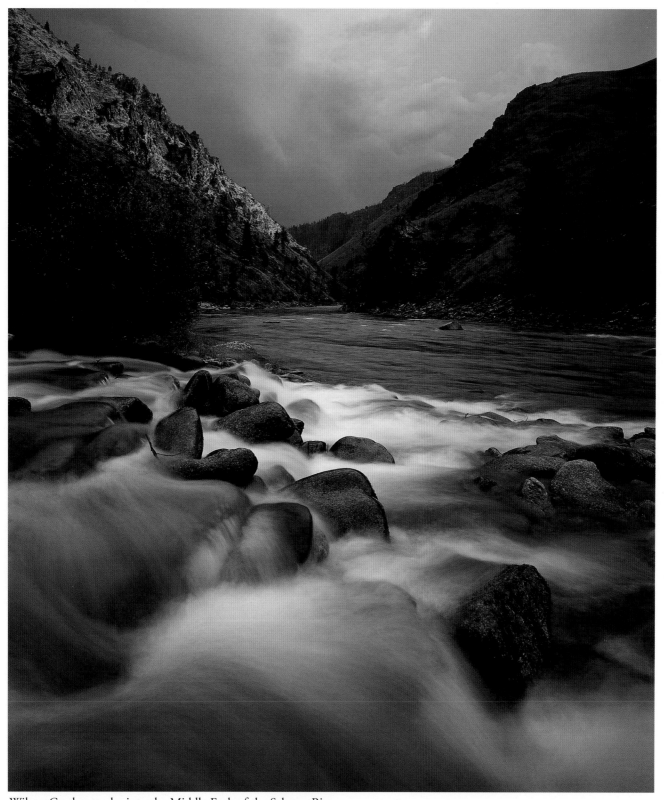

Wilson Creek cascades into the Middle Fork of the Salmon River.

Scott and Shelda Farr ferry a guest from the Thomas Creek airstrip to Middle Fork Lodge, an upscale dude ranch.

The Life

Choice comments in the guest book at the Diamond D Ranch say it all:

"No TV, no phone, no computer, no newspaper. Keep it that way."

"Good guides, great food and just plain great people."

"Perfect in every way."

Tom and Linda Demorest, owners of the Diamond D, operate a dude ranch near the headwaters of Loon Creek, on the edge of the Frank Church-River of No Return Wilderness. It's a gorgeous spread of buildings, alfalfa fields, horse stables, and a private lake on a large green flat where three creeks converge, Loon Creek, Trail Creek, and the West Fork of Mayfield Creek. Dense forest and rocky granite peaks surround the whole place.

"It is the biggest piece of flat ground anywhere in the whole wilderness," says Tom Demorest, who's been kicking around the Diamond D since he was a 13-year-old kid. "I thought it was the greatest place that I'd ever seen."

Demorest's dad, "Big Jack," bought the place in 1960. Tom and his dad cleared the fields so they could grow alfalfa pastures for cattle and horses. "Most of this land was sagebrush and rock," he says.

Initially, the Diamond D was set up as a guest ranch for summer pack trips and fall hunting trips, and they raised cattle on the side. The hunting business has always been strong because of healthy big-game populations in the surrounding public lands, and a long string of experienced guides. In the fall, Demorest and his guide, Rob Coddens, set up hunting camps in their territory in the Frank Church Wilderness and help elk hunters find a prized animal. They also do some guided mountain lion hunting, and spring bear hunting.

"The wildlife is just phenomenal here," says Coddens, a broad-shouldered fella who looks stronger than an ox. "I'm really into big-game hunting, that's why I work here. You can't go to too many places in the world and see the variety of game you can see here. We've got deer, elk, bighorn sheep, mountain goats, moose, golden eagles and birds of prey, black bear, cougar and wolves. I've seen them all in this country, and at times, I've seen them all on this ranch."

In the old days, Demorest and his dad caught salmon galore. "When I was young, the salmon were thick in here," he says. "Loon Creek was just loaded, from one end to the other, with salmon. It was something to see."

Eventually, Tom Demorest phased out the cattle business and focused on the guest ranch in the summer and fall. During the summer, guests can do all kinds of things at the Diamond D. They can hang out by the lap pool. They can read in the comfy living room of the lodge and, if they're brave, challenge Tom Demorest to a game of cribbage. They can play volleyball on the spacious, well-manicured green lawn in front of the lodge. Or they can go hiking, fishing or horseback riding.

"This ranch is a fantastic opportunity for people who know nothing about this country," he says. "They don't have to have any outdoor skills at all. They can just come here, and we'll show them a good time. This is for America."

Demorest is adamant that guests must leave their cell phones and computers behind. Kids have to leave their electronic gadgets at home, too.

"We'll see families dragging their kids through the door at the beginning of the week, and by the end of their trip, they're dragging them by the hair to leave. The kids have had such a good time, they don't want to leave. Anyone who stays a week leaves a part of their soul out there," he says.

Demorest has had some powerful businessmen argue about turning off their cell phones, but eventually, they're grateful. "If you can't dial it down here, you can't dial it down anywhere," he says. "People talk about the stress in their life, and I tell them to go up on this ridge and see really how infinitesimal they are. It usually works pretty good."

The Diamond D dude ranch experience is emblematic of what tourists can expect at similar destinations in the Salmon River Country, such as Rocky Mountain Ranch near Stanley, Wapiti Meadows Ranch on the South Fork, Shepp Ranch on the Main Salmon, and Twin Peaks Ranch, near Salmon.

Tourists certainly enjoy their time in the Salmon River Country, but for full-time residents, life can have its ups and downs. It's difficult to make a living in Central Idaho — large employers with high-paying wages simply don't exist — limiting most people's jobs to things like cattle ranching, mining, and the recreation business.

Many residents focus on the recreation and tourism industry because it's the most promising growth industry right now. Travel and convention business, for example, grew by 18 percent in Lemhi County in the last five years of the 1990s, and it expanded by 25 percent in Idaho County.

Hotels in Stanley, Challis, Salmon, Riggins, and Grangeville — the towns that ring Salmon River Country — provide rooms for people passing through to go whitewater boating, camping, big-game hunting and steelhead fishing. Retail shops like Riverwear in Stanley, Rendezvous Sports in Salmon, and Gravity Sports in McCall, provide all the outdoor gear. Restaurants with true country charm keep the tourists fed before and after wilderness trips.

Husband-and-wife outfitting businesses provide whitewater boating trips, steelhead fishing trips, hunting trips, and summer pack trips. Dude ranches provide a place for tourists to stay in comfy country quarters while they go horseback riding, hiking, cross-country skiing and fishing. Air taxi services provide quick access into the backcountry for floaters, backpackers, hunters, anglers and backcountry skiers throughout the year.

Tom and Linda Demorest have six grown children, three boys and three girls, all of whom have spent a lot of time at the Diamond D. In the summer of 2000, their youngest daughters Dana, 24, and Kara, 25, were working at the ranch, leading horseback trips.

"It's a phenomenal amount of work. There's really no end to it," Demorest says. "Sometimes I'll stop and look at an alfalfa grove, and you just don't know how pretty that is."

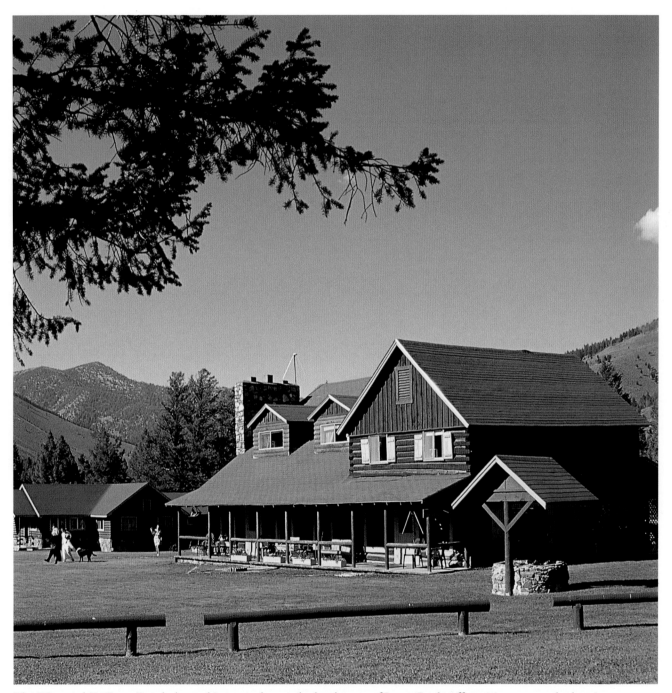

The Diamond D Guest Ranch, located in a meadow at the headwaters of Loon Creek, offers visitors rest and relaxation.

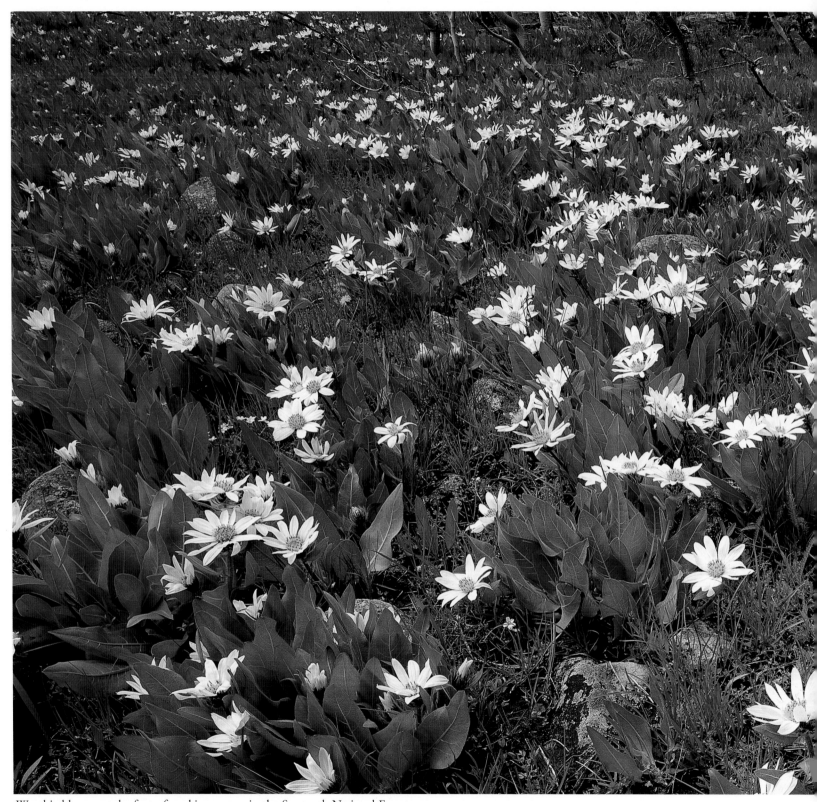

Wyethia blooms at the foot of quaking aspens in the Sawtooth National Forest.

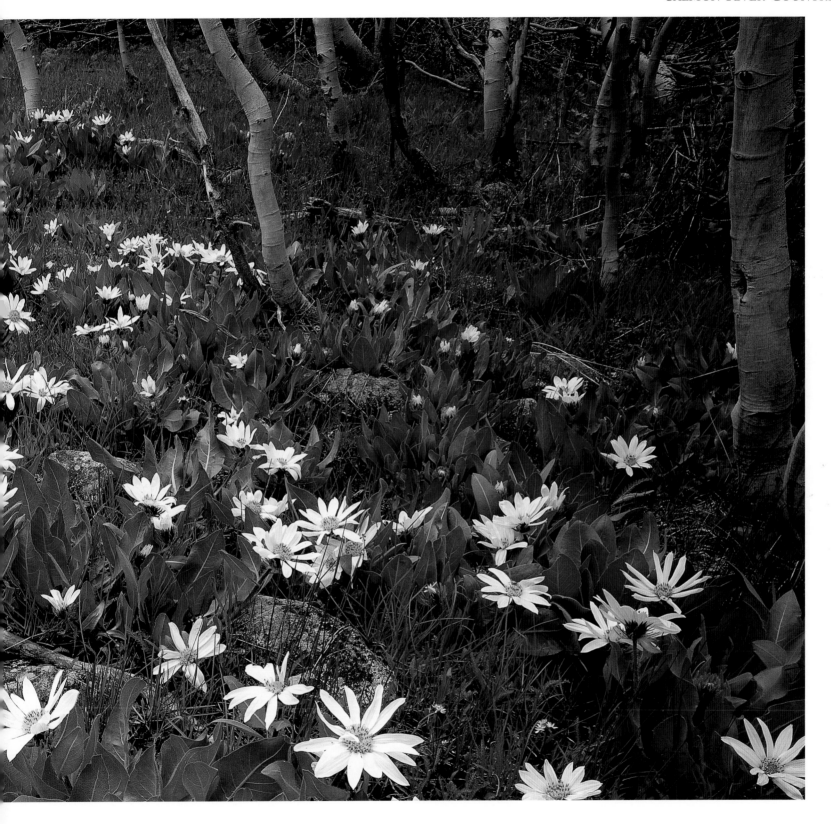

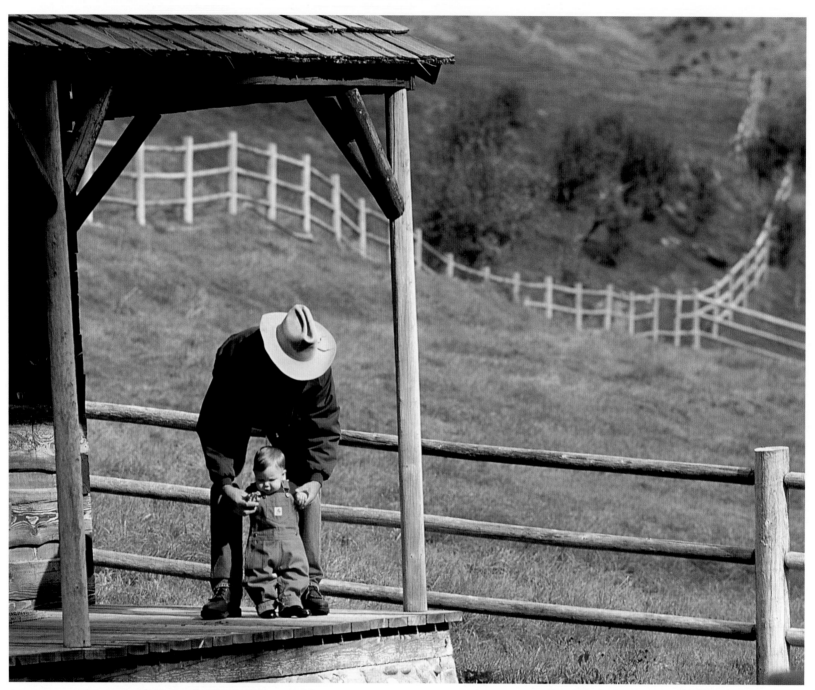

Mark Troy and son Silas check out the porch of the Middle Fork Lodge. Mark and Kristin Troy have raised two kids while managing the wilderness lodge.

Mules and horses from Middle Fork Lodge form large pack strings for summer excursions and fall hunting trips.

Harp jammin' at the Yellow Pine Harmonica Festival.

The Life

The Salmon River Country is a place where some families live a true frontier lifestyle, with no running water, no electricity and outdoor privies. Children are home-schooled. Muzzy and JoAnn Braun in Slate Creek near Stanley raised four boys, all of whom were home-schooled and grew up in a primitive lifestyle They became accomplished musicians, like their father, whose original band was called the Braun Brothers. Muzzy and his boys have yodeled and played guitar and fiddle on the Jay Leno Show to a nationwide audience on NBC-TV.

Salmon River Country communities come up with unique ways to survive, too.

Every summer, on the first weekend of August, the streets are cleared in Yellow Pine, Idaho (population 40), for the annual harmonica contest. A wooden stage is set up on the south end of town, and wooden benches are laid out in between the Yellow Pine General Store and two restaurants and bars. It's time for HarpFest, one of the largest harmonica festivals in the western world. Thousands of spectators come to watch old-timers and youngsters play the harp and listen to the cowboy poets.

The harmonica festival reveals an earnest effort by Yellow Pine's sturdy residents to create new activities that will draw tourists to this remote village (it's a four-hour drive from Boise, and two hours from Cascade and McCall), and revitalize the town. My, how it has worked.

"We had 300 people show up the first year, and this year

Logan Kerr

(HarpFest 2001), we're expecting 3,000 to 5,000 people," says a grinning Dave Enel, a longtime Yellow Pine resident and HarpFest organizer.

This is a big event for Yellow Pine. The town sits in a deep pocket surrounded by tall mountains blanketed with ponderosa pine at the confluence of Johnson Creek, Profile Creek and the East Fork of the Salmon River. White granite spires and monoliths protrude from a carpet of green adding accent to the scene overlooking town.

It's a beautiful place — like a postcard from the old West. Almost on cue, an old codger with a long gray beard rides a horse down the main street while a fellow plays a tune on stage.

The contest draws some of the best talent in the West, and tourists flock to the area from Idaho and most of the adjoining states, Nevada, Utah, Montana, Wyoming, Oregon, and Washington, as well as California.

Enel counsels that everyone should be sure to attend the Crowd Pleaser contest on Saturday night. "You're in for a ride like you've never had before," he says. "Hold onto your pants."

He's not kidding. These fun-lovin' harpists can churn out the notes like you've never heard before. They make people get up and dance, and feet begin to stomp on the floor to the beat.

You'll see every kind of harmonica imaginable, too. Three guys in their 80s sit on the sidelines under a "Fire Danger Extreme" sign and jam with the guys on stage. One has a special belt with five harps wrapped in leather sheaths. Another has a 18-inch-long harmonica, and the third plays a double-decker harp that completely covers his face. They all crank out the notes while a little girl plays with a yo-yo in the front row.

A Middle Fork Lodge wrangler fuels his mount.

Isolated Shoup, Idaho, is the former home of George Shoup, one of the state's early governors.

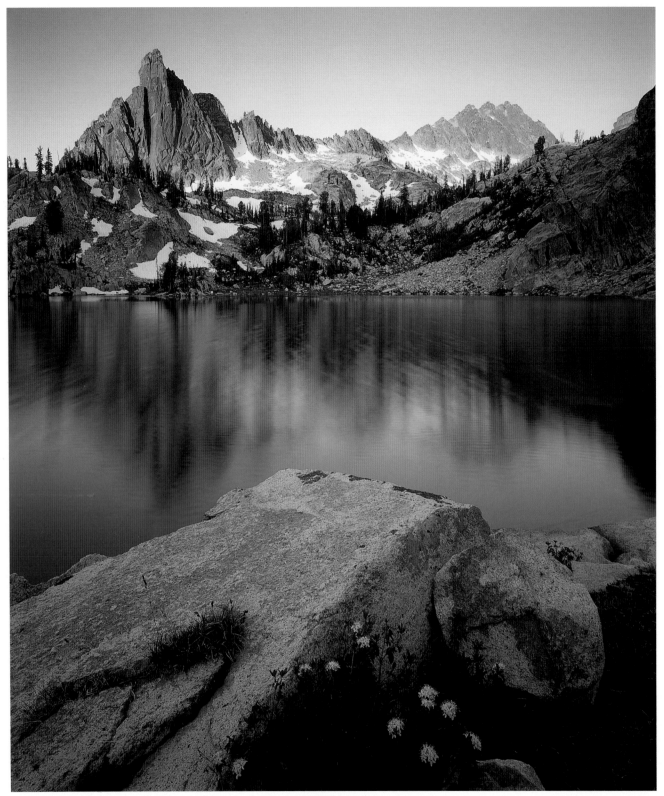

Evening light illuminates the Finger of Fate in the Sawtooth Wilderness.

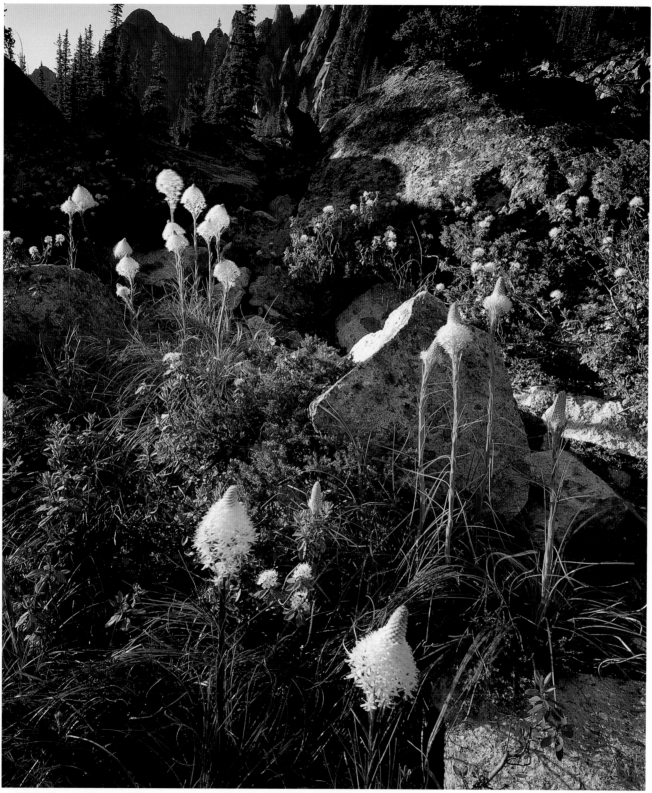

Trailside bear grass punctuates the beauty of backpacking in the Bighorn Crags.

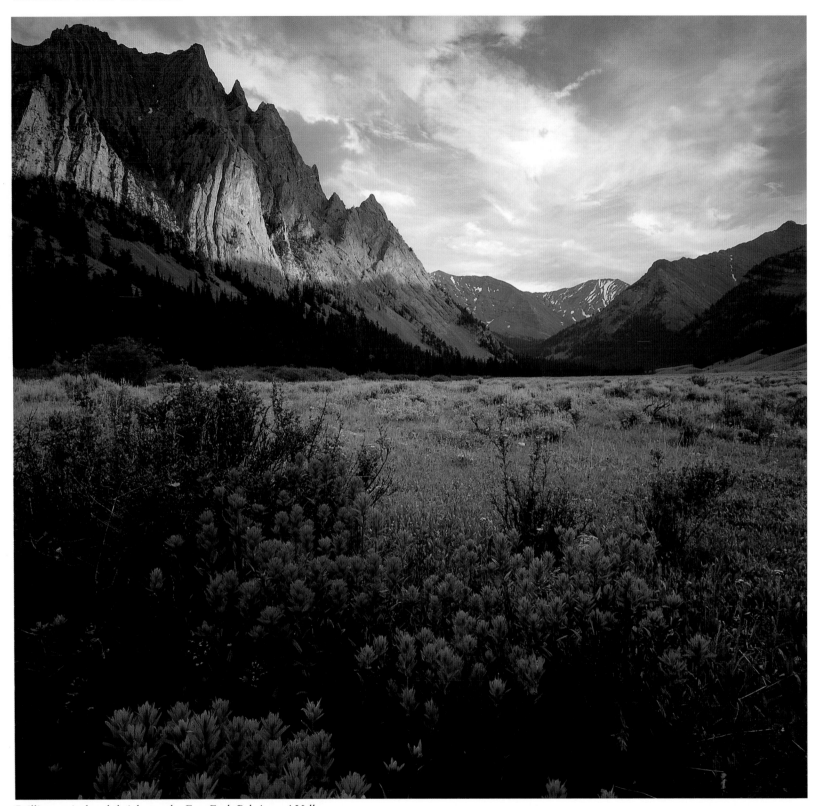

Brilliant paintbrush brightens the East Fork Pahsimeroi Valley.

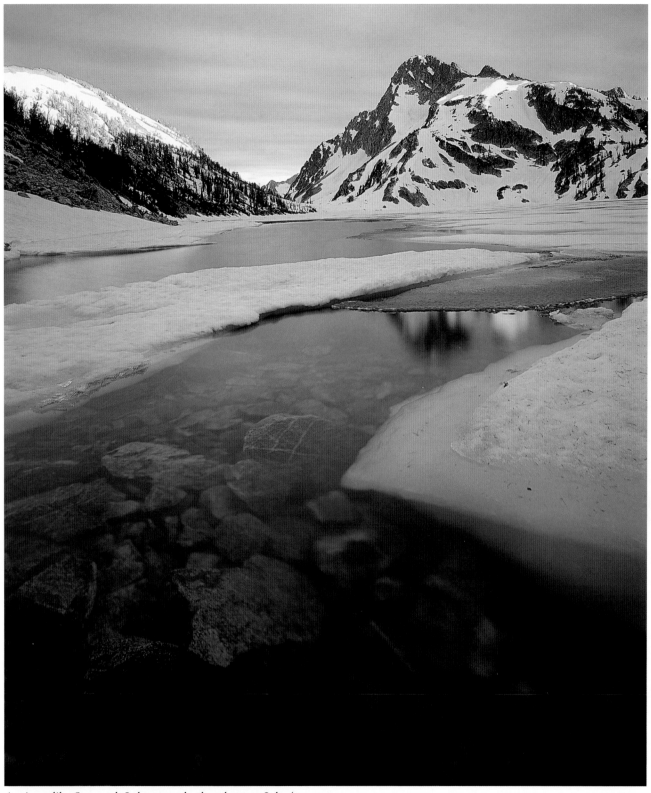

A winter-like Sawtooth Lake greets backpackers on July 4.

Snow

It is snowing hard on a pleasant mid-January morning on the Bench Lake Trail. I'm out in front of our eight-person group, breaking trail through feather-light snow, and I can feel myself drifting into this delightful zone of great contentment with every forward stride.

I marvel at the quarter-sized giant snowflakes, and pause for a moment to tilt my head backward, open my mouth wide, and let a few flakes fall into my mouth, just to feel the tangy taste.

It's such a joy to be here in the Sawtooth Mountains in the wintertime, when the Salmon River Country takes on a markedly different aura than any other time of year. When the November and December snows put a fresh downy quilt of white over the mountains, and frosty temperatures arrive in force, human visitors dwindle to a trickle and mother nature dominates the landscape with her icy grip.

The little burb of Stanley, the hub of the upper Salmon River Country, shrinks to its true population of 71 residents — or even fewer, depending on how many locals decide to brave Idaho's coldest spot for the winter. Deep snow and avalanche hazards can close Idaho State Highway 21 for weeks or months.

By the peak of the winter, the mighty Salmon River gets silenced by a continuous cap of snow and ice, from the headwaters to points near Riggins.

Nightfall at the Bench yurt

"When winter hits, this area becomes a forgotten corner of the world," says Kirk Bachman, a professional rock-climbing guide and longtime Stanley resident. "It's like the closest thing to Alaska, without being there."

At times like this, only the toughest, most rugged mountaineers head into the Salmon River Country to camp in the snow, scale an icy chandelier or ski impossibly steep chutes. On this January trip in the Sawtooths, our group has booked the Bench Lake Hut through Sun Valley Trekking, a Ketchum-based outfitter that has five yurts and wall tents available for rental in the Sawtooths and Smoky Mountains.

The Bench Hut, a 30-foot wall tent that lies directly below 10,154-foot Heyburn Peak, is equipped with enough bunks to sleep 12, a triple-burner propane stove for cooking, two wood stoves for heat, all the kitchen utensils — cups, plates, pots and pans, and silverware, and a sauna to boot. All you have to bring are your sleeping bag, clothes, drinks, and food for the long weekend. It's a much more cushy experience than winter camping. I can go out and ski all day, get all sweaty, and look forward to having a great meal in heated quarters, and take a sauna before bed.

On this particular Friday morning, my adrenaline meter is beginning to run into the red zone because of all the fresh snow. I know the skiing is going to be absolutely to-die-for in the glades above the Bench hut. Two of my friends are equally enthused, and after we reach the hut, we ditch our big packs and grab our smaller day packs, shovels and snacks for a few runs before dinner.

With adhesive climbing skins on the bottom of our

telemark skis, we zigzag up the slopes above the hut — slopes former Sun Valley Trekking owner Bob Jonas calls the "crapper" slopes — because they're located just above the outhouse. At times, the term can apply to the quality of skiing above the hut, when it gets too warm, and the south slopes get coated with a continuous layer of breakable crust. But that's not the situation today.

We reach the ridge and glide through the light snow to a slope that trends to the southeast. We rip off our skins, and then, the proverbial question, who's going first? We didn't need to dig a pit to gauge snow-stability, because the slope is barely 30 degrees in steepness, and we didn't hear a single "whump" on the climb up. Everything appears stable.

"I'll go," says Tom Harper. And he points his tips downhill, leaving a spray of fine flakes in his wake. He weaves a couple of perfect tele turns, and we hear "wa-hoo!"

Marianne Nelson takes off next and finds her own perfect line. I move about 20 yards from their tracks, and go for it. Just like I thought, it's the sweetest of sweet conditions, like a magic carpet ride through glades of trees. I've had plenty of time on my skis this winter, so I don't even have to think about what I'm doing. I just enjoy the poetry of the telemark turn as I fly directly down the fall line.

I ski up to Tom and Marianne at the bottom of the hill, and they're grinning like Cheshire cats. I roll my head back and utter my best mountain howl.

"Another?" Tom says.

"Oh, yeah."

Kirk Bachman

Every once in a while, the snowflakes are perfectly aligned for a perfect ski trip. I've been backcountry skiing so many times when it's not perfect, when you run into rotten snow, breakable crust, brutal winds, whiteouts, whatever. So when everything lines up on your side, you've got to seize the day.

On a weekend in late March, a group of seven of us ski into the Williams Peak Yurt in the Sawtooths. It had been snowing for several days, laying down at least 18 inches of light snow for us to enjoy for three days.

I knew we had nailed the conditions when Kirk Bachman, owner of Sawtooth Mountain Guides, takes me for a quick run after arriving at the yurt. Bachman zig-zaggs up a slope behind the yurt to the top of a glade of trees, and shoves off, making a series of perfect parallel turns down the slope. I follow suit. It's going to be an awesome weekend.

On Saturday, we climb to Skiers Summit on a snow-capped rocky knob, just under the shadow of 10,635-foot Williams Peak. It looks huge above us, with a yellow-cake like color and a giant hanging brow. To the south, we have a big view of Thompson Peak, at 10,751 feet, the tallest in the Sawtooths.

Bachman calls the Skiers Summit "one of the seven wonders of the Salmon River Country." We can't disagree. Across the Sawtooth Valley, I watched Castle Peak and countless other cloud-like white granite peaks rise like an elevator as I climb higher and can see deeper into the interior of the range. To the south, we see a full panorama of the upper Loon Creek country, the peaks above the headwaters of the Middle Fork, and more — just a total 360-degree view of the Upper Salmon River Country, all stunningly beautiful, all cloaked in white.

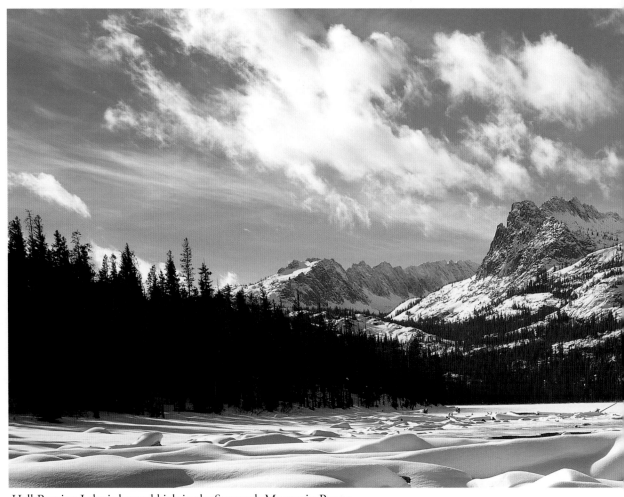

Hell Roaring Lake is located high in the Sawtooth Mountain Range.

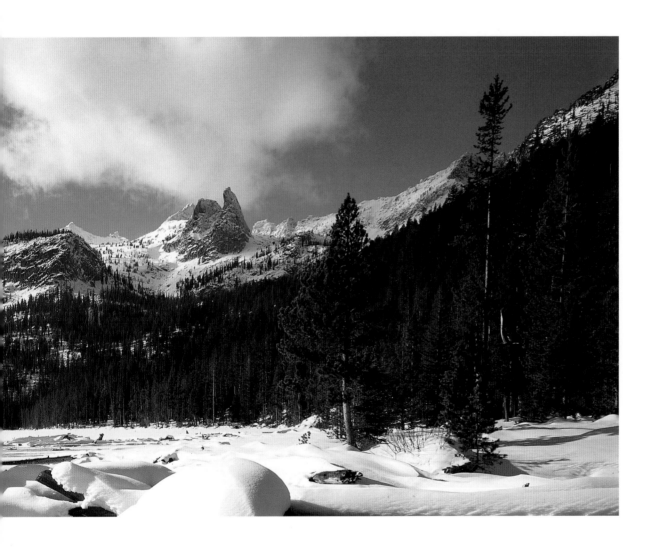

Joe Tonsmeire – Ice Man

In the middle of winter, when he's not tending to his Holstein cattle on his Lemhi Valley ranch, Joe Tonsmeire, 54, likes to take a break and go ice climbing. He's probably the only rancher in Lemhi County who does that sort of thing — actually, he's one of only a handful of people in the Salmon area who knows how to climb ice — but he's not a typical rancher.

Tonsmeire came to the Salmon River Country from the Deep South in 1971 in search of adventure. He ended up starting a river business, Wilderness River Outfitters, and later started a land-based business in the summer for guided horseback trips in the remote Lemhi Mountains. He ran rivers like the Tatshenshini in Alaska, the Middle Fork of the Flathead in Montana, the Owyhee in southwest Idaho, and the Salmon.

Later, he got into the cattle-ranching business as a way to diversify his financial holdings. In the meantime, he and his wife, Fran, raised a daughter and a son in their quaint log home on Hayden Creek. So, in essence, he was a hard-core adventure type of guy before he became a rancher.

Tonsmeire, who has a bushy white mustache, says he likes to climb ice to deflect his focus from other matters. "I enjoy the challenge of it all," he says, "and you're focused to the point where you're not thinking about your overdrawn bank account, the car being broken down, or a sick cow. You're totally focused, mentally rejuvenated, refreshed. It takes total concentration."

For today's climb, Tonsmeire directs us to a 200-foot blue mantle of ice, a waterfall in the spring that's totally frozen now. It's on a north-facing slope in the Salmon River Canyon, near Panther Creek and Pine Creek Rapids, so it never sees the sun all winter long. The ice sheet is framed by multi-colored rocks on a cliff face, blond, white and charcoal jagged outcroppings. We hike to the bottom of the 15-foot-wide sheet of ice.

Tonsmeire's friend and employee, Travis Scott, 28, tags along to assist his boss in the climb. They wear plastic boots and crampons, winter outerwear, a hat and gloves. They have a large ice ax for each hand. They have all kinds of hardware attached to a waist belt, carabiners, and snargs, and safety screws that will be driven into the wall of ice for protection as they climb the ice wall.

Standing right next to the ice wall, it's now easy to see how steep it is.

"I figured if it's not going to be a high-water year, this might be my only chance to scare myself this spring," Scott says with a nervous grin.

"I think I'll have the fear expression today," adds

Tonsmeire.

He steps up to the ice sheet, and smacks the ice axes into the ice to begin the climb. The axes make a hollow kind of "pop" sound when they penetrate the ice. In a matter of 30 seconds, Tonsmeire is ripping up the slope like it's a walk in the park. With each step, he kicks in the two front prongs of the crampons, the only thing holding him on the slope besides his ice axes. With each swing of the ax, he makes sure it's holding in the ice before he takes a step.

Tonsmeire makes it up the first pitch without a hitch, and walks over to a Douglas fir tree off to the side. He ties a sling around the

Joe Tonsmeire, ice-climber,
outfitter and rancher

tree, and belays Scott, while he climbs up the ice sheet. Scott is less experienced, and he's not quite as smooth, but he makes it without incident.

I put my ear against the ice sheet and I can hear melt water trickling and gurgling underneath.

Now it's time for an even steeper pitch, over the top of a couple ice chandeliers. Tonsmeire puts in screws every 10 feet on this pitch in the event of a fall. He takes his time and finds the best route around several dead-vertical mounds of ice.

"I did manage to get scared there for a minute," he says.

Fall comes early at Little Redfish Lake.

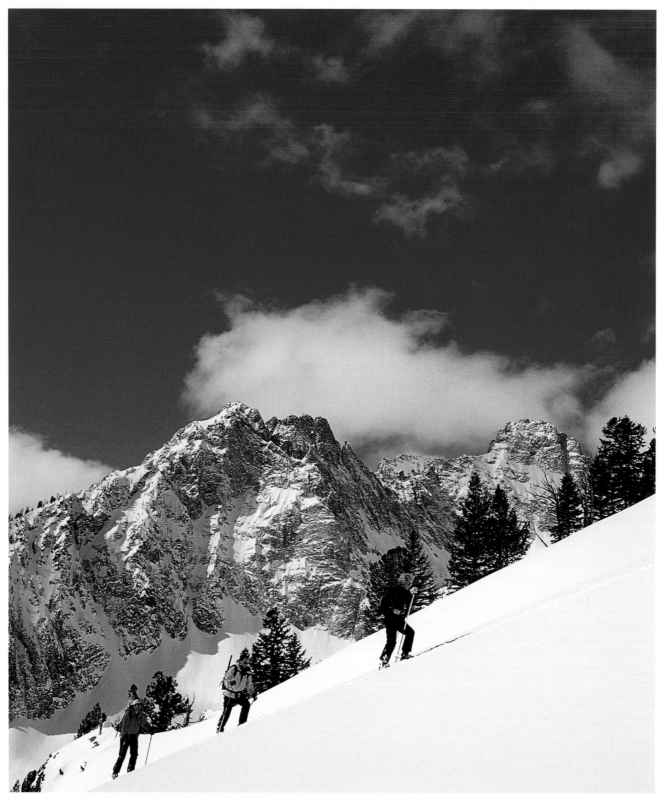

Climbing to Skiers Summit in the Sawtooth Wilderness.

For a free Caxton catalog write to:

CAXTON PRESS
312 Main Street
Caldwell, ID 83605-3299

or

Visit our Internet web site:

www.caxtonpress.com

Caxton Press is a division of The CAXTON PRINTERS, Ltd.